Anni Albers Selected Writings on Design

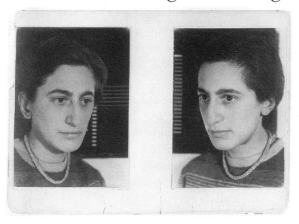

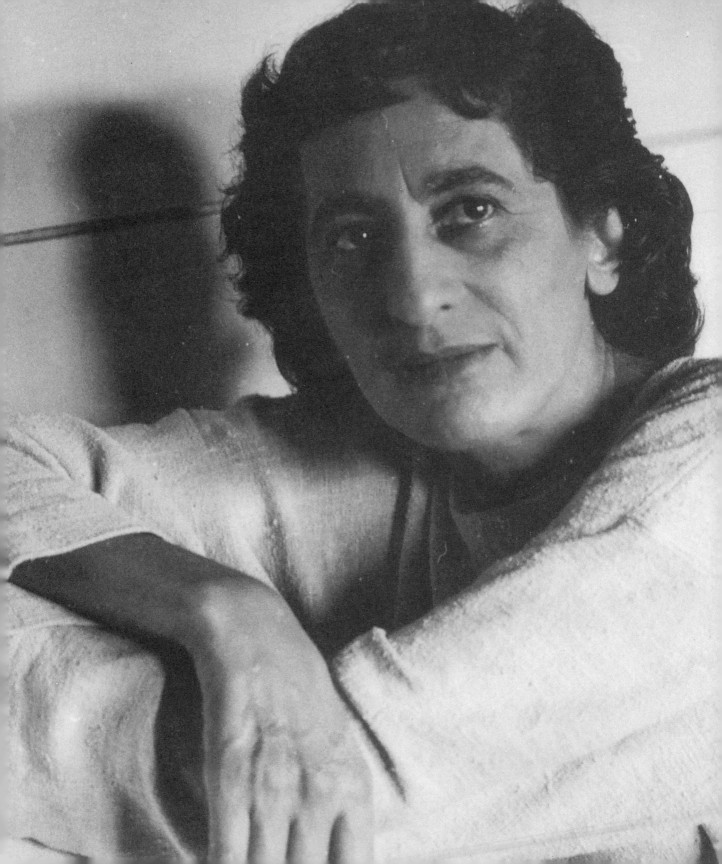

Anni Albers Selected Writings on Design

Edited and with an introduction by

Brenda Danilowitz

Foreword by Nicholas Fox Weber

WESLEYAN UNIVERSITY PRESS

Published by University Press of New England

Hanover & London

WESLEYAN UNIVERSITY PRESS

Published by University Press of New England,

Hanover, NH 03755

Printed in the United States of America

5 4 3 2 1

Library of Congress
Cataloging-in-Publication Data
Albers, Anni.
 Anni Albers : selected writings on design / edited and with an
introduction by Brenda Danilowitz ; foreword by Nicholas Fox Weber.
 p. cm.
Includes bibliographical references.
 ISBN 0–8195–6447–8 (cloth)
 1. Design—Philosophy. 2. Decoration and ornament—Philosophy.
I. Danilowitz, Brenda. II. Title.
NK1505.A38 2000
701'.8—dc21
 00–010582

CONTENTS

Illustrations follow pages 16, 32, and 64.
Captions for the portraits of Anni Albers appear on page 80.

Anni Albers had an approach to writing that bore a stunning resemblance to the process of creating a weaving on a loom. Using her manual typewriter, she would write her text on ordinary white 8½-by-11-inch sheets of paper and then tape the pages together as if to create a scroll. She felt that only in this way could she achieve and judge the flow and continuity of the completed essay; at least initially, she did not want the barrier imposed by the need to turn the page.

Content, of course, was essential, but so were the aesthetics of writing. As in her textiles, she sought a mix of understatement and strength, a graceful tone, a relationship of the parts that was harmonious but never repetitious or boring.

The whole notion of language was one of her passions. She was intrigued by the appearance of hieroglyphics and of various ancient scripts. Her art reflects in a vague way the appearance, at times, of Arab or Hebrew alphabets, of Oriental calligraphy, of ancient Mayan lettering. With those alien but enticing tongues it was not the meaning that mattered so much as the timbre and general feeling: the wonderful, urgent need to communicate. That need and the music of writing sometimes transcended the specifics of the available media of expression.

But words, and the English language, were vital; she would master them as best she could. Having had an Irish governess when young, this German-speaking woman had a good start on the tongue that would be essential to her once she and her husband Josef, also German-speaking, were forced to leave their native country in 1933 and move to Black Mountain, North Carolina. Anni used to cite several specific influences as being of pivotal importance: President Franklin Delano Roosevelt, who felt "like a benevolent uncle" (not that she or Josef ever met him) and whose fireside chats offered such comfort (she also liked his fine command of words and aristocratic

diction); and Alfred North Whitehead, whose command of English she found as clear and precise as his name.

Using words as she did thread, linking them and tying them together as effectively as possible, she put her marvelous aesthetic philosophy, her truest belief system, on the typewritten pages that became those scrolls. The results are both eloquent and profound. And it is more than appropriate that they are now being assembled in this new form by Wesleyan University Press, the institution that made the two marvelous books of Anni's lifetime, that endorsed and helped perpetuate her intellect and vision some three decades ago. (It also delighted Anni that Wesleyan published John Cage, for even if his spontaneity was at times quite the opposite of her taste for planning and preparation, they were both spiritual adventurers whose pioneering approach as well as innate humor strengthened the friendship that existed between them for nearly half a century.) It is equally fitting that the person who has researched and helped assemble this volume is Brenda Danilowitz, a friend and colleague to Anni, a true scholar of her work as well as close acquaintance of the woman herself. These arc some of the reasons that the pages that follow are so true to the inventive, sure, and, now more than ever, influential belief system of Anni Albers.

Anni Albers had a singular talent for dissecting puzzling relationships. Where less acute minds might perceive contradiction, her instincts were to recognize, grasp, and mine a paradox to extract its most trenchant significance. She was perfectly capable, as well, of framing her own paradoxes to challenge received wisdom. "Wholeness is not a Utopian dream," she proclaimed in "Design: Anonymous and Timeless" (1947), and then went on to test this juxtaposition in her work as a designer and creator of textiles and works on paper. Albers relished bending her mind around paradoxical relationships. It may have been especially apparent to her that, like the two sides of a textile, which are created simultaneously but are commonly characterized in the exclusionary terms of either *right* or *wrong*, a paradox can be defined by its indivisible relationship of opposing terms. As the one surface develops, its underside inevitably takes shape. If you unravel the one side, the other comes apart.

Anni Albers came of age during World War I and its tumultuous aftermath in Germany. Her maturity—and the bulk of her writing—coincided (barely a decade later and from a new and distant vantage point across the ocean in the U.S.A.) with the chaos of World War II. Themes of the confusion and chaos of life, on the one hand, and the order and balance that art can bring to it through courageous work, on the other, are reiterated in her writings. "Weaving at the Bauhaus" (1938) opens, "In a world as chaotic as the European world after World War I." "Work with Material" (1937), which begins, "Life today is very bewildering," and "One Aspect of Art Work" (1944), "Our world goes to pieces," echo this introduction. In each case it was clear to her, and she makes it clear to us, that in the life of the true artist these confusions can feed the creative impulse. Her ideas were formed and grounded in the European modernist experience of the 1920s and early 1930s. Together with its belief that art embodies universal principles, modernism put its faith in the ideal that art and design

could profoundly affect and even transform life. Characteristically by the 1940s, when her writings began to appear in American journals, she meshed this philosophical framework with her enthusiasm for American pragmatism and freedom.

As portrayed in "A Start" (1947), her tribute to Walter Gropius, founder of the Bauhaus, the world she entered as a novice in 1922 provided a welcome refuge. Unlike many of the enrolling students at the Bauhaus in Weimar, Albers had scant prior training as an artist. Describing this particular place and time with a clarity that has eluded many other commentators, she observed the continuity between past and present. Writing from a post-1945 perspective, she was perfectly placed to acknowledge that the "experience of realizing sense and meaning in a world confused" and the quest of "finding one's bearing" are at once time-bound and universal, existing "now as then." In a perennially uncertain world, art was the lodestar by which Anni Albers would continue to orient herself. And she defined true art by its qualities of wholeness, balance, order, and resolution. "Art—A Constant" (1939) has her weighing this faith against those other constants—religion, philosophy, and science—and finding it superior.

"Wholeness is not a Utopian dream." It may be daunting, but it is attainable, not through complacency but through courage. Because, Albers reminded artists over and over, true creativity involves fearless (but not reckless) risk taking. For the artist of courage, the flip side of confusion and chaos is the excitement that accompanies discovery and invention. Providing a context for these ideas, "Weaving at the Bauhaus," a text written for the catalog of the 1938 Museum of Modern Art exhibition *Bauhaus 1919–1928*, and revised in 1959, points out how important it was for Bauhaus artists and designers to confront their confusing times boldly. The resolution of form and the revolutions in design they helped bring about were achieved intuitively, first by courageous experimentation and a willingness to give up old ideas, and second by slow progress and joint effort in which "each reacted according to his ability."[1]

One of Anni Albers's most emphatic convictions, and a topic she returned to repeat-

1. "Weaving at the Bauhaus," p. 3.

edly, was her faith that materials hold the key to the creative process. Bauhaus methods proposed an understanding of the capabilities of materials as the base from which design and art took off. Albers explored the implications of this principle in ways that extend the modernist concept of "truth to materials." Wholeness is demonstrated when the ingenuity of the artist, put in the service of a chosen material, produces an ideal situation—the congruence of form with function (or content) that makes for a universal, harmonious, and ultimately transcendent creation. She knowingly frames a further paradox as she exhorts artists to follow where their materials lead yet at the same time to push the capabilities of those materials to unexpected limits: "To circumvent the NO of the material with the YES of an inventive solution, that is the way new things come about—in a contest with the material."[2]

A different, though equally crucial contest—between fine and applied art—arose in Albers's work as a weaver and designer of textiles. She addressed the perennial dichotomy of art and craft by placing them, not in opposition to one another, but on a continuum in which every craft object has the potential to be art. In such a nonhierarchical system an unschooled individual is as likely as a highly schooled one to create a masterpiece—more likely, in fact, since theoretical knowledge can be useless knowledge and an impediment to creation. Such ideas have a long history. They would have had common currency at the Bauhaus, where Paul Klee and Wassily Kandinsky were influential teachers. But Albers took up the art/craft debate in a very specific way. She revered ancient craftspeople and especially the early Andean weavers for the ingenious ways they produced objects of great beauty from extremely limited resources, and she peremptorily and acerbically dismissed "the hobbyist, this new subspecies of craftsman," who, with abundant and easily available materials, made meaningless objects. These she discarded as "ashtray art . . . trash," while she redefined craft as inventive and innovative "work with materials."[3]

2. "Conversations with Artists," p. 52.
3. "Constructing Textiles," p. 29.

When it came to the opposition of the handmade and the machine-made object, Albers was a convincing advocate for a symbiotic rather than an adversarial relationship. Both methods of fabrication have their place in the creative process, where they can mutually enrich one another. The craftsman should take advantage of technology—new materials and processes—to contribute to industry the creative ideas that inject a spark into an often unimaginative machine production. Without referring directly to her own art, she made it clear that her work aimed at such a union. She was a tireless experimenter with all manner of fibers and yarns, combining them into inventive structures that were prototypes for mass-produced textiles. Anni Albers had great ambitions for textiles. She refuted conventional classifications of weaving as a homely, feminized pastime and aligned textiles with architecture. "The Pliable Plane: Textiles in Architecture" (1957) is an original and compelling argument for textiles and the work of the textile designer and artist as an intrinsic part of construction rather than mere added embellishment.

Writing itself invited her to question the relative powers of written and visual languages. Early on, when Albers was a young student at the Bauhaus in 1924, her ability to write crisp prose without sacrificing complex ideas was recognized. She was one of the students selected to state the Bauhaus position in articles that appeared in popular magazines of the day.[4] Adept as she was at verbal expression, she considered the work of her beloved Andean weavers a powerful visual stand-in for written language. Visual language—especially in an abstract idiom—had the added advantage of being universally understood. Soon after Albers settled in the United States in late 1933, she began writing in her adopted language. Spoken English was familiar to her from childhood, since she had had an English-speaking governess, but writing profession-

4. "Wöhnökonomie," in *Neue Frauenkleidung und Frauenkultur*, vol. 1 (1925) and "Bauhausweberei," *Junge Menschen* 5:8 (Nov. 1924, p. 188). These short pieces, written to promote the young school and its philosophy, were fairly unambiguous statements of the Bauhaus ideals that became staples of modernism.

ally was a new challenge. Finding the appropriate words to write her mental processes may have sharpened her conviction that, being universal, visual statements were potentially more effective than spoken or written ones. Several of Anni Albers's thematic weavings (which she called pictorial weavings) confirm her interest in visual language as an alternate form of communication—*Ancient Writing, Code, Haiku, Open Letter* are some of the titles she gave them.

When the occasion demanded, however, Anni Albers turned to words to express her ideas. Her expression, like her art, is richly textured. The meaning is never in doubt. She draws the reader in, then inexorably, step by step, builds up an argument in her unique and idiosyncratic style. Her writing is at once so dense and so precise that it is impossible to paraphrase. Reading her words and following her thought processes is as rewarding as contemplating one of her intricate woven creations. Not all her writings were originally intended for publication. When she gave a lecture or participated in a panel discussion, she would invariably compose the text in advance. Whether she was addressing the Black Mountain College Women's Club ("Talk on Jewelry," 1942) or her fellow artists (College Art Association panel, "Material as Metaphor," 1982), her writings present a compact and lucid entry to modernist ideas. "I try to avoid the twilight," she concluded in "Conversations with Artists" (1961).

Though her life spanned a century of vast and rapid change, Anni Albers's writings show her steadfast commitment to ideas about art and design that she absorbed early on and that continued to sustain her creativity until the end. In 1982 she restated and summarized her beliefs and the paradoxes that fueled them: "material is a means of communication. . . . listening to it, not dominating it makes us truly active, that is: to be active, be passive."[5] Though unmistakably a product of their time, her ideas affirm fundamental notions that continue to resonate in conditions far removed from the early decades of the twentieth century.

5. "Material as Metaphor" (1982), p. 73.

Anni Albers Selected Writings on Design

I came to the Bauhaus at its "period of the saints." Many around me, a lost and bewildered newcomer, were, oddly enough, in white—not a professional white or the white of summer—here it was the vestal white. But far from being awesome, the baggy white dresses and saggy white suits had rather a familiar homemade touch. Clearly this was a place of groping and fumbling, of experimenting and taking chances.

Outside was the world I came from, a tangle of hopelessness, of undirected energy, of cross-purposes. Inside, here, at the Bauhaus after some two years of its existence, was confusion, too, I thought, but certainly no hopelessness or aimlessness, rather exuberance with its own kind of confusion. But there seemed to be a gathering of efforts for some dim and distant purpose, a purpose I could not yet see and which, I feared might remain perhaps forever hidden from me.

Then Gropius* spoke. It was a welcome to us, the new students. He spoke, I believe, of the ideas that brought the Bauhaus into being and of the work ahead. I do not recall anything of the actual phrasing or even of the thoughts expressed. What is still present in my mind is the experience of a gradual condensation, during that hour he spoke, of our hoping and musing into a focal point, into a meaning, into some distant, stable objective. It was an experience that meant purpose and direction from there on.

This was about twenty-six years ago.

Last year some young friends of mine told me of the opening speech Gropius gave at Harvard at the beginning of the new term. What made it significant to them was the

* Walter Gropius, founder of the Bauhaus, Germany, and later chairman of the Department of Architecture in the Graduate School of Design, Harvard University.

experience of realizing sense and meaning in a world confused, now as then—the same experience of finding one's bearing.

1947

(Unpublished contribution for a book on Gropius which did not materialize. Subsequently published in Craft Horizons *29:5, Sept.–Oct. 1969, as an obituary for Walter Gropius who died on July 5, 1969.)*

In a world as chaotic as the European world after World War I, any exploratory artistic work had to be experimental in a very comprehensive sense. What had existed had proved to be wrong; everything leading up to it seemed to be wrong, too.

Anyone seeking to find a point of certainty amid the confusion of upset beliefs, and hoping to lay a foundation for a work which was oriented toward the future, had to start at the very beginning. This meant focusing upon the inherent qualities of the material to be used and disregarding any previously employed device for handling it.

At the Bauhaus, those beginning to work in textiles at that time, for example, were fortunate not to have had the traditional training in the craft: it is no easy task to throw useless conventions overboard. Coming from Art Academies, they had felt a sterility there from too great a detachment from life. They believed that only working directly with the material could help them get back to a sound basis and relate them with the problems of their own time.

But how to begin? At first they played with the material quite amateurishly. Gradually, however, something emerged which looked like the beginning of a new style. Technique was picked up as it was found to be needed and insofar as it might serve as a basis for future experimentations.

Unburdened by any considerations of practical application, this uninhibited play with materials resulted in amazing objects, striking in their newness of conception in regard to use of color and compositional elements—objects of often quite barbaric beauty. Such a free way of approaching a material seems worth keeping in mind as far as the work of beginners is concerned. Courage is an important factor in any creative effort. It can be most active when knowledge in too early a stage does not narrow the vision.

One of the outstanding characteristics of the Bauhaus has been, to my mind, an unprejudiced attitude toward materials and their inherent capacities. The early,

improvised weavings of that time provided a fund of means from which later clearly ordered compositions were developed, textiles of a quite unusual kind. A new style started on its way. Little by little the attention of the outside world was aroused and museums began to buy these weavings.

A most curious change took place when the idea of a practical purpose, a purpose aside from the purely artistic one, suggested itself to this group of weavers. Such a thought, ordinarily in the foreground, had not occurred to them, having been so deeply absorbed in the problems of the material itself and the discoveries of unlimited ways of handling it. This consideration of usefulness brought about a profoundly different conception. A shift took place from the free play with forms to a logical building of structures. As a result, more systematic training in the construction of weaves was introduced and a course in the dyeing of yarns added. Concentrating on a purpose had a disciplining effect, now that the range of possibilities had been freely explored.

The realization of appropriateness of purpose introduced also another factor: the importance of recognizing new problems arising with changing times, of foreseeing a development. As Alfred North Whitehead says, on foresight: "the habit of foreseeing is elicited by the habit of understanding. To a large extent, understanding can be acquired by a conscious effort and it can be taught. Thus the training of Foresight is by the medium of Understanding. Foresight is the product of Insight." The creative impetus, previously coming from the world of appearance, now received stimulus from the intellectual sphere of a recognized need. Only the imaginative mind can bring about the transformation of such rational recognition into a material form.

Physical characteristics of materials now moved into the center of interest. Light-reflecting and sound-absorbing materials were developed. Utility became the keynote of work, and with it the desire to reach a wider public than before. This meant a transition from handwork to machine work when large production was concerned. It was realized that work by hand should be limited to laboratory work and that the machine was to take over where mass production was involved. With this new orientation the interest of industry was aroused.

A desire to take part actively in contemporary life by contributing to the forms of its objects was much alive in our minds. And we realized that revised aesthetic values and technical advances each bring about a change of attitude, the one influencing at first the few; the other, less subtly, the many.

The changing inclination of that period affected those working in the Bauhaus workshops and each reacted according to his ability, trying to help toward the building of new forms. The work as a whole was the result of the joint effort of a group, each member contributing his interpretation of an idea held in common. Many of the steps taken were intuitive rather than clearly conceived, and it is only in retrospect that their impact has become evident.

September 1938 (revised July 1959)

WORK WITH MATERIAL

Life today is very bewildering. We have no picture of it which is all-inclusive, such as former times may have had. We have to make a choice between concepts of great diversity. And as a common ground is wanting, we are baffled by them. We must find our way back to simplicity of conception in order to find ourselves. For only by simplicity can we experience meaning, and only by experiencing meaning can we become qualified for independent comprehension.

In all learning today dependence on authority plays a large part, because of the tremendous field of knowledge to be covered in a short time. This often leaves the student oscillating between admiration and uncertainty, with the well-known result that a feeling of inferiority is today common both in individuals and in whole nations.

Independence presumes a spirit of adventurousness—a faith in one's own strength. It is this which should be promoted. Work in a field where authority has not made itself felt may help toward this goal. For we are overgrown with information, decorative maybe, but useless in any constructive sense. We have developed our receptivity and have neglected our own formative impulse. It is no accident that nervous breakdowns occur more often in our civilization than in those where creative power had a natural outlet in daily activities. And this fact leads to a suggestion: we must come down to earth from the clouds where we live in vagueness, and experience the most real thing there is: material.

Civilization seems in general to estrange men from materials, that is, from materials in their original form. For the process of shaping these is so divided into separate steps that one person is rarely involved in the whole course of manufacture, often knowing only the finished product. But if we want to get from materials the sense of directness, the adventure of being close to the stuff the world is made of, we have to go back to the material itself, to its original state, and from there on partake in its stages of change.

We use materials to satisfy our practical needs and our spiritual ones as well. We have useful things and beautiful things—equipment and works of art. In earlier civilizations there was no clear separation of this sort. The useful thing could be made beautiful in the hands of the artisan, who was also the manufacturer. His creative impulse was not thwarted by drudgery in one section of a long and complicated mechanical process. He was also a creator. Machines reduce the boredom of repetition. On the other hand they permit a play of the imagination only in the preliminary planning of the product.

Material, that is to say unformed or unshaped matter, is the field where authority blocks independent experimentation less than in many other fields, and for this reason it seems well fitted to become the training ground for invention and free speculation. It is here that even the shyest beginner can catch a glimpse of the exhilaration of creating, by being a creator while at the same time he is checked by irrevocable laws set by the nature of the material, not by man. Free experimentation here can result in the fulfillment of an inner urge to give form and to give permanence to ideas, that is to say, it can result in art, or it can result in the satisfaction of invention in some more technical way.

But most important to one's own growth is to see oneself leave the safe ground of accepted conventions and to find oneself alone and self-dependent. It is an adventure which can permeate one's whole being. Self-confidence can grow. And a longing for excitement can be satisfied without external means, within oneself; for creating is the most intense excitement one can come to know.

All art work, such as music, architecture, and even religion and the laws of science, can be understood as the transformed wish for stability and order. But art work understood as work with a substance which can be grasped and formed is more suited for the development of the taste for exploration than work in other fields, for the fact of the inherent laws of material is of importance. They introduce boundaries for a task of free imagination. This very freedom can be so bewildering to the searching person that it may lead to resignation if he is faced with the immense welter of possibilities; but

within set limits the imagination can find something to hold to. There still remains a fullness of choice but one not as overwhelming as that offered by unlimited opportunities. These boundaries may be conceived as the skeleton of a structure. To the beginners a material with very definite limitations can for this reason be most helpful in the process of building up independent work.

The crafts, understood as conventions of treating material, introduce another factor: traditions of operation which embody set laws. This may be helpful in one direction, as a frame for work. But these rules may also evoke a challenge. They are revokable, for they are set by man. They may provoke us to test ourselves against them. But always they provide a discipline which balances the hubris of creative ecstasy.

All crafts are suited to this end, but some better than others. The more possibilities for attack the material offers in its appearance and in its structural elements, the more it can call forth imagination and productiveness. Weaving is an example of a craft which is many-sided. Besides surface qualities, such as rough and smooth, dull and shiny, hard and soft, it also includes color, and, as the dominating element, texture, which is the result of the construction of weaves. Like any craft it may end in producing useful objects, or it may rise to the level of art.

When teaching the crafts, in addition to the work of free exploring, both the useful and the artistic have to be considered. As we have said before, today only the first step in the process of producing things of need is left to free planning. No variation is possible when production is once taken up, assuming that today mass production must necessarily include machine work. This means that the teaching has to lead toward planning for industrial repetition, with emphasis on making models for industry. It also must attempt to evoke a consciousness of developments, and further perhaps a foreseeing of them. Hence, the result of craft work, work done in direct contact with the material, can come here to have a meaning to a far wider range of people than would be the case if they remained restricted to handwork only. And from the industrial standpoint, machine production will get a fresh impetus from taking up the results of intimate work with material.

The other aspect of craft work is concerned with art work, the realization of a hope for a lawful and enduring nature. Other elements, such as proportion, space relations, rhythm, predominate in these experiments, as they do in the other arts. No limitations other than the veto of the material itself are set. More than an active process, it is a listening for the dictation of the material and a taking in of the laws of harmony. It is for this reason that we can find certitude in the belief that we are taking part in an eternal order.

1937

ART — A CONSTANT

Times of rapid change produce a wish for stability, for permanence and finality, as quiet times ask for adventure and change. Wishes derive from imaginative vision. And it is this visionary reality we need, to complement our experience of the immediate reality. On the equilibrium of the two depends our happiness. When we are resigned to a fact as a last conclusion, our drive for action dies. The various forms of balance, brought about by imaginative vision, to supplement the experience of what we consider actuality, are the topic under consideration.

One formulation of such completing forces has come from religion. It has given hope to despair and fear to self-indulgence. Balance, however, needs equal weight. Thus, religious formulation must be transposed into the positiveness of dogma to endow it with a cogency as strong as reality. A dogma also gratifies a wish for permanence since it stands as final. But, paradoxically, dogmatic finality has a short life: the security of permanence provokes us to look for change, and moreover, dogmatic finality responds to merely temporary conditions and thus, in turn, becomes transient. Modifications and interpretations gradually vary its once absolute meaning. Thus, supremacy breaks down when invaded by variations, for we grow skeptical where we can choose. Where there is an alternative, change can be foretold—a change of that which once had the unchangeable authority of finality.

Also, philosophic speculations have found compensations for our clash with a confusing reality. For, in tidying up the universe, they have by means of generalizations, reduced an inconceivable infinity to comprehensible measure and function. Disclosing the coherence of occurrences, they have given us some measure of understanding and thereby consoled us. Every age demands new evidence for such universal connectedness, although, at some periods, philosophic doctrines, similar to religious dogmas, have seemed final. Any change of accent, however, brings about a new set of

concepts. In the history of philosophy one truth after another has arisen and de-clined. We can appreciate past systems of thought and admire them, but usually only by giving up our standpoint of today and by trying to reason in terms of another era. Only rarely is it possible to apply today a system of thought developed in another epoch, and when we find one suited to our present needs, it almost always concerns only a part and not the whole of a system.

Although science, too, has as its task the clarification and simplification of our no-tion of nature, our idea of ultimate completeness has to exclude a scientific approach. Science, in essence, is more "here" than "there." It supplies us with a classified cata-log of our tangible world; it measures and it explains processes of matter; it even pro-jects into the unexplored, but always it is on this side of our existence. Science in its nature is not transcendental.

The fusion of this "here" and "there" is art. It is the forming of a vision into mate-rial reality. Differing from religious or metaphysical ideas which are tinged by the general contemporary posture and so are subject to change, art directs itself to our lasting fundamental spiritual, emotional, and sensuous needs: to the spirit by embod-ying an idea, prophecies, criticism; to the emotions through rhythm, harmony, dy-namics; to the senses through the medium of color, sound, texture. The aim of art is to gratify our lasting needs and it absorbs and passes beyond the imprints that tempo-ral influences may have on them. It transcends the merely personal in our desires. And though most art can be classified as belonging to a specific time and place and though it often has the stamp of a definite author, still, great art is in essence unaf-fected by subjectiveness, by period and location, and does not pass through the cycle of rise and fall. Art is always new and radiates through any sediment of contemporary meaning. Obscuring to some degree the direct experience of art are modes of taste, i.e., inclinations of periods toward specific forms, overlaying the general and lasting assertions of art. Tastes are expressions of transitory demands and are of powerful and often devastating effect. They exalt that which answers a momentary inclination to prominent position and condemn what does not appeal to them. Tastes, at times, can

coincide with the lasting formulation of a period, but often, unfortunately, they diverge. Only time shows what outlasts momentary tendencies and has true greatness. (Stendhal, criticizing Voltaire, says that wit lasts no more than two centuries.) We can experience the efficacy of taste in the recurring fact that contemporary opinion rarely recognizes a work of lasting and prophetic nature. Manifestations of genius are mostly not in keeping with their time and therefore remain either unnoticed or meet violent rejection by contemporary opinion. They are recognized and accepted when the indifference or protest brought about through transitory taste have passed and their lasting nature can become evident.

We also have the difficulty that today only a few people are genuinely responsive to art, for it presupposes susceptibility to a form of communication other than rational or symbolical. Although art presents itself directly and not emblematically, it seems that civilization easily spoils us for such direct receptivity.

Today we find ourselves again in search of a lasting truth. Our world changes rapidly and often we feel perplexed and filled with doubt. Our inner insecurity seems strangely reflected in the events of the day. We see a belief in violence (the cause of violent conflicts) in contrast to a growing disbelief in it. Such mistrust, once the notion of only a few, is gradually turning into the conviction of masses. But more than such contradictory tendencies of our time, we feel our uncertainty even in our habits of thought. For instance, having once placed implicit trust in the principle of efficiency, we now, at times, pause and wonder, seeing it sometimes distorted. We have to re-examine even our automatic reasoning.

It is always difficult to comprehend one's own time. Because, living in it, the presuppositions of beliefs are obscured by their very familiarity: the customary is outside the realm of questioning and so is easily overlooked. What we are clearly aware of today is our feeling of amazed confusion. (Note increasing nervous disorders.) We realize in consternation that we find ourselves questioning religious or philosophic thought for not immediately giving us the unquestionable assurance we are looking for.

A decisive aspect of this general feeling of instability is due to today's technique of communication. Since it stresses the moment, i.e. the temporary, it accelerates the process of rise and fall of ideas. We see different beliefs in quick succession or simultaneity, contradicting each other, overlapping each other, complementing each other. Faced with such devastating multiplicity, we are often forced to submit to indecision or to opinions, easily changeable, not worth being called convictions.

Recognizing such unstabilizing effects, dictatorships have tried to build up some faiths artificially by limiting and censoring communication with the outside world and even within their borders. But faith needs freedom and time to mature. What can be produced artificially is merely fanatic obsession.

At some periods we have found religious belief giving us the stabilizing—or to use a word of the moment—tranquilizing supplement of ideas, at others, philosophic thought has done so. Science, too, has tried to give us the needed equilibrium, but it has had to postpone indefinitely answers to our questions concerning the ever receding unknown. And sometimes art, the ancient magic, has had this power.

All these forces which direct our wishes and satisfy them in varying form seem to be finding a common denominator now in our concept of education. Education has grown beyond the initial stage of suggesting methods of bringing up the young and conveying a stock of information. We hope for education today to impart to us that balance which we need: a trust in constancy and permanence. But as yet education has not developed to this point. So far it only mediates and sets a direction. But from such beginning one day may come a new formulation, because, unlike religion and philosophy, education has a better chance to develop uninhibited by dogmatic requirements upon it. And because we do not quite know what education may become someday, we feel free to ask for new and revealing answers from it, answers involving ethics, morals, aesthetics.

In answer to our need for a fulcrum, education, in its capacity as a directing agent, may point to art as withstanding the chances of time. For only art is left to us in unchanging absoluteness. But, not apparent to all of us, we find it often strangely

obscured. Layer after layer of civilized life seems to have veiled our directness of seeing. We often look for an underlying meaning of things while the thing itself is the meaning. Intellectual interpretation may hinder our intuitive insight. Here education should undo the damage and bring us back to receptive simplicity. It is obvious that a solely intellectual approach to art is insufficient and that we may have to try to redevelop those sensibilities which can lead to immediate perception. Only thus can we regain the faculty of directly experiencing art.

As all art is form in some material, we may have in material the indication of the way we might make the necessary adjustments in our rather one-sided development. Work with material, a material of our tangible surroundings, will give us some insight into those principles of nature to which we all are subjected. We can recognize in material a willing bearer of ideas which we superimpose upon it, provided they are conceived in accordance with its structure. Such insight gained from a real substance will hold for all media of art. A balanced interplay of passive obedience to the dictation of the material on the one side and of active forming is the process of creating. Working with material in an imaginative manner, we may come out at the end with an understanding of art or with a work of art. For as material alone gives reality to art, we will, in forming it, come to know those forces which are at work in any creation.

Recognizing in matter its potentialities and its limitations may also help us clarify the ideas of the medium in art when it is immaterial. This idea of the medium in art is often misunderstood. A distinction is necessary, to any artistic end, between the medium serving a purpose outside itself and the medium in its own right as for instance words used for reporting vs. words used in poetry. Some media have to be released from their representative meaning to make them fit an artistic purpose. Words and gestures, as an example, are binary in that sense. As they are often not clearly recognized in their specific capacity as elements of form, they are often chosen as means by those who feel some vague urge for expression. They seem to be materials familiar to us through their daily use. But as media of art they have to be newly mastered just as any other material has to be.

Work with a substance which can actually be handled is manual work. It has two aspects, if we limit it to work which involves a complete process of shaping an object from start to finish, that of free, and that of traditional, forming of material: art and craft. Between these two poles all grades of ability to shape material can find their place. But the more we move to free exploration, the greater vision is demanded and the greater our insight will be.

Such work by hand may seem in this time of mechanical processes rather futile. But in many cases we have thought also of mathematics, despite the beauty of its formulations, as merely speculative and useless in a practical sense. Often it meant chiefly a means of intellectual training. However, it has brought results of great advancement in science. Manual work in this form may also lead to an unforeseen impetus in art.

This work can also mean a deviation from a too one-sided intellectual reasoning and will swerve from a process determined by the will to a process of alert quiescence. Our subjective intent for a task may turn into objective devotion to it. We will then feel that our own responsibility is taken over by those energies which affect our balance and will act in accordance with them. For, forming a material means giving shape to our wishes in terms of a hoped-for completion.

Both results of such work, the cognizance of art, and the making of art, will make us happier, because to comprehend art means to confide again in a constant, and to create art makes us an acting part of the completing forces.

The more works of art there are, the more statements we will have of an unchanging answer to unchanged questions. From religion and philosophy may come again answers to demands set by a period. Unhindered by obscuring factors such as art meets them, they can be more effective than art at a given epoch. The religious and philosophic attitude itself is constant, but it is transitory in its formulations. Art is also constant in its form.

The objects of nature are what we consider to be reality. Art objects are objects of both reality and vision.

The reality of nature will appear to us as never ending, for we know nature only as part of nature. As we examine it, it is endless. It obeys laws never totally lucid to our understanding.

The reality of art is concluded in itself. It sets up its own laws as completion of vision.

Art is constant and it is complete.

November 1939

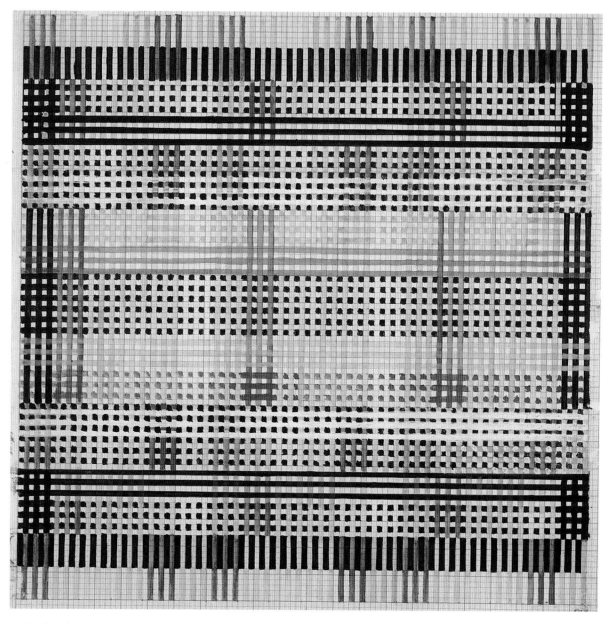

Design for tablecloth, Bauhaus, Dessau, Germany, 1930.
Watercolor and gouache on square-ruled paper, 26 × 24.1 cms (10$^{1}/_{4}$ × 9$^{1}/_{2}$ ins).
The Museum of Modern Art, New York. Gift of the designer.
Photograph © 2000 The Museum of Modern Art, New York. 393.51

Wall Hanging, 1926. Silk (two-ply weave), 182.9 × 122 cms. Courtesy of the Busch-Reisinger Museum, Harvard University Art Museums, Association Fund. Photograph by Michael Nedzweski. © President and Fellows of Harvard College, Harvard University. BR 48.132

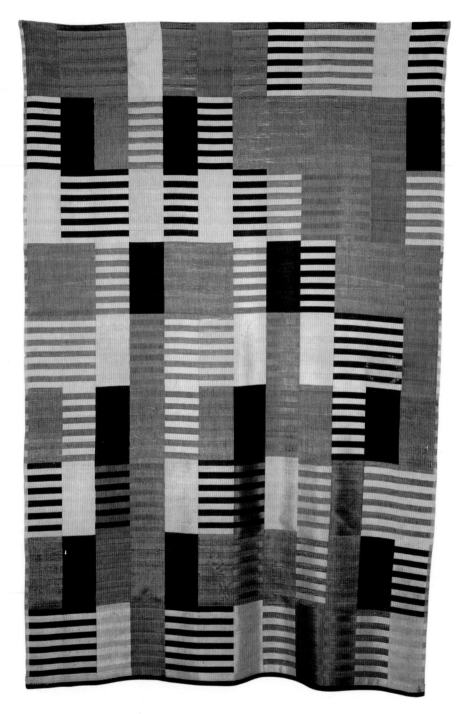

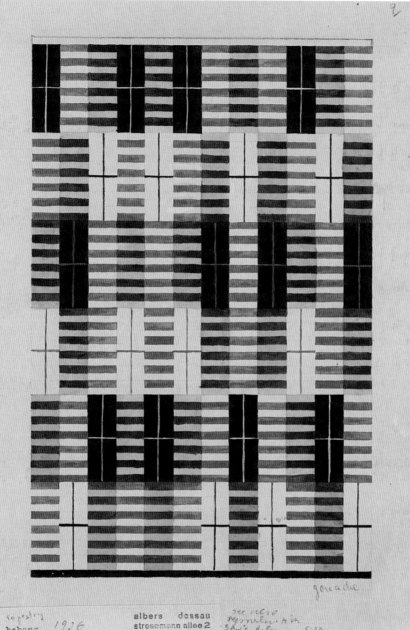

Design for wallhanging, 1926.
Gouache on paper, 31.8 ×
20.6 cms (12 1/2 × 8 1/8 ins).
The Museum of Modern Art,
New York. Gift of the designer.
Photograph © 2000 The Mu-
seum of Modern Art, New
York. 401.51

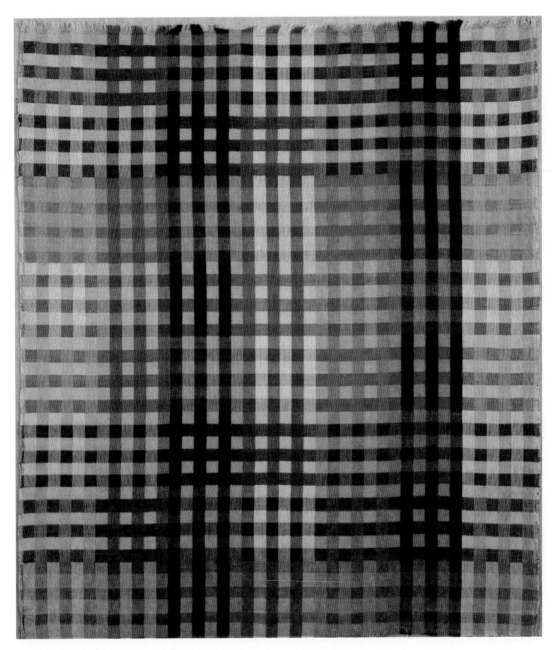

Tablecloth material, 1930.
Mercerized cotton, 59.3 × 72.4 cms (23³/₈ × 28¹/₂ ins).
The Museum of Modern Art, New York. Purchase Fund.
Photograph © 2000 The Museum of Modern Art, New York. 561.53

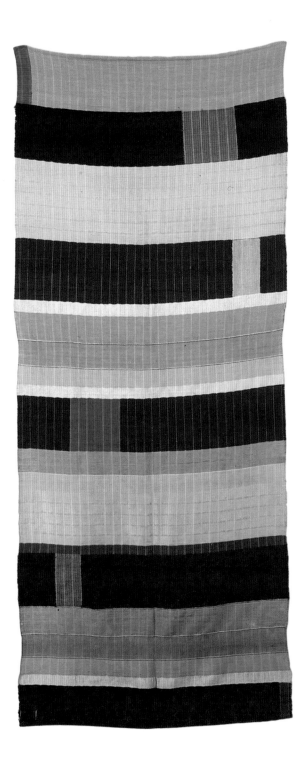

Untitled wallhanging, 1925.
Wool and silk, 236 × 96 cms
(92^{7}/$_{8}$ × 37^{13}/$_{16}$ ins). Die Neue
Sammlung Staatliches Mu-
seum für angewandte, Kunst,
Munich. 364/26

Drapery material, 1927. Cotton and rayon, 15.9 × 10.8 cm (6 1/4 × 4 1/4 ins). The Museum of Modern Art, New York. Gift of the designer. Photograph © 2000 The Museum of Modern Art, New York. 450.51

Wall covering material for auditorium of Bundesschule in Bernau, Germany, 1929. Cotton, and cellophane, 22.9 × 12.7 cms (9 × 5 ins). The Museum of Modern Art, New York. Gift of the designer. Photograph © 2000 The Museum of Modern Art, New York. 433.51

Upholstery material, ca. 1929.
Cotton and rayon 11.4 × 19.4 cms (4 $\frac{1}{2}$ × 7 $\frac{5}{8}$ ins).
The Museum of Modern Art, New York.
Gift of Josef Albers.
Photograph © 2000 The Museum of Modern Art, New York. 450.70.61

Among the shells on a shore lies a button. In its accurate roundness and evenness it is a queer object here side by side with the diversified forms of nature.

Most man-made things bear such a mark of simplified and obvious orderliness and regularity. Nature is mysterious in her work and multiform. In her hands our button on the beach will become variegated in shape and surface and finally will come to resemble a shell.

In all practical work we curiously reverse nature's way though we know her to be supreme. We find her unsurpassable in variations, while we tend to uniformity. Though she is free in change, we seek, bewildered, more permanent forms. Only in work having no immediate purpose—in art work—do we try to practice her mode of shaping things and thus give up our inconsistency.

If in art work we venture to follow nature by learning from her rich variety of form, at the other pole of our work, the developing of tools, we reduce form to its barest essentials. Usefulness is the dominant principle in tools. They do not exist, like works of art, for their own sake but are means to further ends. Some early tools of stone, representations of the human figure, do not show this opposition, since they themselves are sometimes art. They are understood as magical, useful beings, helping us work, but even in their anthropomorphic form they have the accuracy and simplicity which distinguishes all work of man. It has been a long way from these early forms to the complicated mechanism of modern machines. In our tools today, however, we can still recognize the image of an arm in a lever. That it is no longer man as a whole that is represented is significant, for actually machines do specialized work, a work of just a section of us. The invention of the wheel stands as an amazing feat of abstraction, translating motion instead of outer shape into new form. It is a further step toward the division, still in progress, between art forms and technical forms. (Which does

not mean that abstracted forms cannot become the elements of a piece of art.) The concentration on function, which is the main task in the making of tools, brings about concise and unencumbered forms. Today we are peculiarly conscious of the purity of these forms among the many objects of our daily surroundings that lack this clarity of conception.

Even though tools appear to express usefulness most truly in their form, we can also find lucid and plain fitness to purpose in unobtrusive objects of our environment. So much do we take them for granted that we are rarely aware of their design. They vary from the anonymous works of engineering to the modest things of our daily life— roads and light bulbs, sheets and milk bottles. We feel no need to endow these quietly serving objects with qualities other than functional ones. In their silent and unassuming existence, they do not call for much of our attention nor do they demand too much time to be spent on their care; neither do they challenge our pride in possessing them. We would not think of collecting light bulbs or sheets to impress our fellow men.

Although we like some things to be restrained, in others we ask for an additional quality of provocative beauty. The form of an object which has been dictated solely by fitness is often beautiful, but in a quiet and reticent way. The engaging quality we ask for may be independent of this form, something given to it. Proportion or color or surface treatment can be such an extra quality, bearing this happy sensation we are looking for; a curtain of plain cloth may answer all demands of its use, but when in colors, it will perhaps please us more. We feel that much of our work is incomplete without these further qualities and even associate polishing with finishing.

Today, trying to regain singleness of purpose in the things we make, proportion, color, and texture concern us most as completing qualities. We still carry with us, however, manners of perfecting things which belong to another time, the time that was controlled by the craftsman. When a piece of work was in his hands from beginning to end, he could elaborate on the shape and add patterns as a natural development in its completion. But there remain now only a few things which we form one by one, as the craftsman does. We deal today with mass production, and as a result the

process of manufacture is necessarily broken up into separate stages, each one in different hands. Thus decorating too has become a separate unit of work, and as such is often only incidental. What once in the hands of the craftsman had been an organic transmutation of form is now often little more than a postscript. But we continue to decorate, searching for aesthetic pleasure, though the conditions of work have changed. Without adding new form values, we obscure the function of things by decorating them. Our decorating today is frequently only camouflage; we make bookends representing animals, vases for flowers themselves resembling flowers. Through decorating we have also learned the trick of hiding a poor material under a rich pattern. Moreover, through ornament we give modest things undue emphasis. Since we have far more things than people had in former times, the rivalry among these objects becomes great. No common rhythm of design can tie them together: our chairs cry "hey" and our ashtrays "ho"! We aesthetically overcharge our surroundings.

Rightly or wrongly, we strive for beauty by adding qualities like color, texture, proportions, or ornamentation; yet beauty is not an appendage. When it unfolds free of considerations of usefulness, it surpasses, as art, all the other work we do. In works of art our characteristic uniformity, obviousness, and regularity are lost in the search for a synonym; in terms of form, for an inner relation. It is easy to detect the human mind behind it, but like nature, it remains in the end impenetrable.

Concerned with form, the craftsman, designer, or artist affects through his work the general trend of style, for better or for worse. The craftsman is today outside of the great process of industrial production; the designer belongs to it. But whether inside or outside, directly or indirectly, he influences the shaping of things. That many imaginative minds find in crafts a wider basis for their work than in the more immediately vital setting of industrial planning is explained perhaps by the more narrow specialization of industry. Unless we propagate handwork as a political means, like Gandhi, the craftsman as producer plays only a minor part today. However, as the one who makes something from beginning to end and has it actually in hand, he is close enough to the material and to the process of working it to be sensitive to the

influences coming from these sources. His role today is that of the expounder of the interplay between them. He may also play the part of the conscience for the producer at large. It is a low voice, but one admonishing and directing rightly. For the craftsman, if he is a good listener, is told what to do by the material, and the material does not err.

The responsibility of the craftsman or artist may go even further, to that of attempting to clarify the general attitude toward things that already exist. Since production as a whole is ordinarily directed today by economic interest, it may take the disinterestedness of the outsider, the craftsman or artist, to make us critical of the consequences. We are used to seeing new needs stimulated and new forms emerging for their satisfaction. Our urge for possessing is constantly nourished; again and again throughout history it has been an underlying cause for war. We will have to be more sensitive to the effect of things on us and to be aware of the implications that come with possessions. For things such as tools call for action; objects of art, for meditation. Things of our more passive existence, those which protect and serve us, give us rest and ease; others may burden and annoy us. They fluctuate from unassuming servitude to challenging sensationalism. We shall have to choose between those bringing distraction or those leading to contemplation; between those accentuating anonymous service or self-centered individualism; between the emphasis on being or on having.

Very few of us can own things without being corrupted by them, without having pride involved in possessing them, gaining thereby a false security. Very few of us can resist being distracted by things. We need to learn to choose the simple and lasting instead of the new and individual; the objective and inclusive form in things in place of the extravagantly individualistic. This means reducing instead of adding, the reversal of our habitual thinking. Our households are overburdened with objects of only occasional usefulness. Created for special demands and temporary moods, they should have no more than temporary existence. But they cling to us as we cling to them, and thus they hamper our freedom. Possessing can degrade us.

Having fewer things sets for the designer or craftsman a fundamentally new task, as it implies designing things for more inclusive use. His attitude will have to be changed from exhibiting personal taste and the exaggeration of personal inclinations in designing to being quietly helpful. He will have to focus on the general instead of on the specific, on the more permanent instead of on the merely temporary. Giving up continuous change does not necessarily mean that we reach a state of stagnation or boredom; it does mean overlooking moods and modes. This stabilization need not be equivalent to limitation, nor need it mean scantiness. It is designing in a manner to hold our interest beyond the moment. Pure forms will never bore us. Neither do we ever tire of nature. We have to learn from her to avoid overstatement and obviousness. These are truly dull. We have to become aware of nature's subtlety and her fine surprises, and to translate these into our idiom. It is easy to invent the extravagant, the pretentious, and the exciting; but these are passing, leaving in us only neurotic aimlessness. The things that have lasted and the things that will last are never subject to quick fashion. That good work and great work have been able to survive we may take as a sign of the good sense in us, buried under temporary nonsense. Instead of adjusting our work to the public demand of the moment, so often misinterpreted and underestimated by our industry, which is concerned with fast-moving mass consumption, let us direct it to this true sense of value underlying public demand.

May 1943

ON JEWELRY

When I was asked to speak here about some work I had been doing together with Alex Reed, student and later teacher at Black Mountain College—a work started quite a while before this war—I was asked too, if I could refer in some way to defense work, in the mind of so many of us the most urgent work of the moment. Though our work has nothing to do with defense work, there was something right in asking to connect it with it. For it is obvious that the urge we feel for doing our part in a catastrophe of such huge proportions as this war stands in the foreground of all of our thoughts. But I think we have found that for many of us our part can not be that of going into a munition factory or that of helping those who suffer in this war in a direct way. Many of us are tied to our homes, to our normal circle of action, to our work continuing as usual. But in all of us, I believe, the need to take some part is accelerating. The work we are doing may have no immediate effect on the outcome of war, as also the work I am going to speak about here will have no influence on it now. But as every action transmits its sense or nonsense beyond its actual radius, whatever we do has its effect. To give our actions the meaning we want them to have implies questioning them anew and becoming conscious of their implications.

The work I am going to speak about here is the work I have been doing together with Alex Reed, student and later teacher, at Black Mountain College. It was not started with any clear knowledge of its possible inferences. Like any other work that has not been tried before, it took on form only by being tried. We knew the direction in which we wanted to go but not where we would end.

You will be astonished, I think, to hear that the first stimulus to make jewelry from hardware came to us from the treasure of Monte Alban, the most precious jewels from ancient Mexico, found only a few years ago in a tomb near Oaxaca. These objects of gold and pearls, of jade, rock-crystal, and shells, made about 1,000 years ago, are of

such surprising beauty in unusual combinations of materials that we became aware of the strange limitations in materials commonly used for jewels today. Gold and silver, pearls or diamonds or their substitutes comprise just about the total scale. Rock-crystal with gold, pearls with simple seashells are beautiful together, we found. We began to look around us and, still in Mexico, we found beads made of onyx, which nobody ever seemed to buy. We saw silverbeads and remembering the Monte Alban combination of rock-crystal and gold, we combined onyx with silver. We made variations of this first combination and later, back in the States, we looked for new materials to use. In the 5 & 10 cents stores we discovered the beauty of washers and bobby-pins. Enchanted we stood before kitchen-sink stoppers and glass insulators, picture books and erasers. The art of Monte Alban had given us the freedom to see things detached from their use, as pure materials, worth being turned into precious objects.

After indulging for a while in new material combinations of our necklaces we soon found the need for good constructions in addition to our strange conjunctions of materials. As we were neither goldsmiths nor knew even the simplest metal work or stone-polishing, we were forced to use materials as we found them as elements for our work. Strangely, we found that having to work with given elements or units brought about new ways of construction, new ways of linking parts together, new catches, new ways of suspending parts. The professional jeweler has means of forming all parts forming a piece of work. His inventiveness in regard to construction depends on reshaping in already given ways, while our amateurish manner of using existing units made new constructions necessary. They were rather forced upon us by the material than being sought by us. We felt more acted upon than acting. I believe a goldsmith would come to many new and surprising results if he reversed at times his usual procedure and would, instead of making all parts to fit a given whole, form independent parts which would challenge his inventiveness and constructive ingenuity in combining.

To our surprise we found that though we used such common materials as bobby-pins or washers or stopper chains for our necklaces they sometimes looked quite beautiful and even precious. To our greater surprise still, we found that other people

liked them too. But our greatest surprise was that others, like ourselves, did not care about the value or lack or value of the materials we used, but enjoyed, instead of material value, that of surprise and inventiveness—a spiritual value.

From the beginning we were quite conscious of our attempt not to discriminate between materials, not to attach to them the conventional values of preciousness or commonness. In breaking through the traditional valuation we felt this to be an attempt to rehabilitate materials. We felt that our experiments perhaps could help to point out the merely transient value we attach to things, though we believe them to be permanent. We tried to show that spiritual values are truly dominant. We thought that our work suggested that jewels no longer were the reserved privilege of the few, but property of everyone who cared to look about and was open to the beauty of the simple things around us. Though so-called costume jewelry has gone in this direction, it is hard to trace in it the simple elements that constitute each piece. We tried to emphasize just this side in our work. We wanted to lead the person looking at our jewels back through the process that brought them about. All things are at their beginning formed in this way of unprejudiced choosing. From time to time, it becomes necessary again to go back to it to clear the way for new seeing.

If we can more and more free ourselves from values other than spiritual, I believe we are going in a right direction. Every general movement is carried by small parts, by single people forming their way of believing and subordinating everything to this belief. We have to work from where we are. But just as you can go everywhere from any given point, so too the idea of any work, however small, can flow into an idea of true momentum.

Black Mountain
March 25, 1942

Our world goes to pieces; we have to rebuild our world. We investigate and worry and analyze and forget that the new comes about through exuberance and not through a defined deficiency. We have to find our strength rather than our weakness. Out of the chaos of collapse we can save the lasting: we still have our "right" or "wrong," the absolute of our inner voice—we still know beauty, freedom, happiness . . . unexplained and unquestioned.

Intuition saves us examination. We have to gather our constructive energies and concentrate on the little we know, the few remaining constants. But do we know how to build? Education meant to prepare us. But how much of education is concerned with doing and how much with recording? How much of it with productive speculation and how much with repeating? Research work and engineering work, when they are creative, are too specialized to give any general basis of constructive attitude. We neglect a training in experimenting and doing; we feel safer as spectators. We collect rather than construct. We have to learn to respond to conditions productively. We cannot master them but we can be guided by them. Limitation from the outside can stimulate our inventiveness rather than confine it. We need such flexibility of reaction in times of crisis. Too much of our education provides instead of prepares and thus loses its serving role and tends to become an end in itself. We are proud of knowledge and forget that facts only give reflected light.

Education in general means to us academic education, which becomes synonymous with an unproductive one. If we want to learn to do, to form, we have to turn to art work, and more specifically to craft work as part of it. Here learning and teaching are directed toward the development of our general capacity to form. They are directed toward the training of our sense of organization, our constructive thinking, our inventiveness and imagination, our sense of balance in form—toward the appre-

hension of principles such as tension and dynamics . . . the long list of faculties which finally culminate in a creative act, or, more specifically in a work of art. On the basis of a creative attitude we can then add necessary information, the specialized studies.

Art work deals with the problem of a piece of art, but more, it teaches the process of all creating, the shaping out of the shapeless. We learn from it that no picture exists before it is done, no form before it is shaped. The conception of a work gives only its temper, not its consistency. Things take shape in material and in the process of working it, and no imagination is great enough to know before the works are done what they will be like.

We come to know in art work that we do not clearly know where we will arrive in our work, although we set the compass, our vision; that we are led, in going along, by material and work process. We have plans and blueprints, but the finished work is still a surprise. We learn to listen to voices: to the yes or no of our material, our tools, our time. We come to know that only when we feel guided by them our work takes on form and meaning, that we are misled when we follow only our will. All great deeds have been achieved under a sense of guidance.

We learn courage from art work. We have to go where no one was before us. We are alone and we are responsible for our actions. Our solitariness takes on religious character: this is a matter of my conscience and me.

We learn to dare to make a choice, to be independent. There is no authority to be questioned. In art work there is no established conception of work; any decision is our own, any judgment. Still, there is one right opinion as to quality of a work of art, spontaneous and indisputable—one of our absolutes. There is a final agreement upon it, of those initiated, no matter how much personal taste or trends of the time influence the judgment.

In making our choice we develop a standpoint. How much of today's confusion is brought about through not knowing where we stand, through the inability to relate experiences directly to us. In art work any experience is immediate. We have to apply

what we absorb to our work of the moment. We cannot postpone the use of what we learn. Much of our education today prepares us for a later day, a day that never comes. Knowing for later is not knowing at all.

We learn to trust our intuition. No explaining and no analyzing can help us recognize an art problem or solve it, if thinking is our only relation to it. We have to rely on inner awareness. We can develop awareness, and clear thoughts may help us cultivate it, but the essence of understanding art is more immediate than any thinking about it. Too much emphasis is given today in our general education to intellectual training. An overemphasis of intellectual work suggests an understanding on a ground which is not the ground of our own experiences. It transposes understanding into assumed experiences which can be right but may be wrong. Our evaluation in school and university is almost entirely an evaluation of intellectuality. The inarticulateness of the artistic person is interpreted easily as a lack of intelligence while it is rather an intelligence expressing itself in other means than words.

Our intellectual training affects our analytic—art work our synthetic ability. We are used to thinking of art work as developing taste or a sense of beauty if not as training artists. We think more of its aesthetic qualities than its constructive ones. But the constructive forces are the ones we will need today and tomorrow. We will have to construct, not analyze or decorate.

That field of art which is the least academic, the least fortified by authority, will be best fitted to prepare for constructive process. The fine arts have accumulated much dignity.

The crafts? They have had a long rest. Industry overran them. We need too much too quickly for any handwork to keep up with. The crafts retreated, a defeated minority. We do not depend on their products now, but we need again their contact with material and their slow process of forming.

The fine arts have specialized on a few materials today, oil paints, water colors, clay, bronze—mostly obedient materials. But any material is good enough for art work. The crafts, too, limited themselves, keeping to woodwork, weaving, etc. But

their materials are less easily subordinated. The struggle with a rugged material teaches us best a constructive discipline.

Resistance is one of the factors necessary to make us realize the characteristics of our medium and make us question our work procedure. We have to parry the material and adjust our plans to those of this opponent. When experimenting, we are forced into flexibility of reaction to it: we have to use imagination and be inventive.

We learn patience and endurance in following through a piece of work. We learn to respect material in working it. Formed things and thoughts live a life of their own; they radiate a meaning. They need a clear form to give a clear meaning. Making something become real and take its place in actuality adds to our feeling of usefulness and security. Learning to form makes us understand all forming. This is not the understanding or misunderstanding we arrive at through the amateur explaining to the amateur—appreciating—this is the fundamental knowing.

The difficult problems are the fundamental problems; simplicity stands at the end, not at the beginning of a work. If education can lead us to elementary seeing, away from too much and too complex information, to the quietness of vision and discipline of forming, it again may prepare us for the task ahead, working for today and tomorrow.

1944

Retrospection, though suspected of being the preoccupation of conservators, can also serve as an active agent. As an antidote for an elated sense of progress that seizes us from time to time, it shows our achievements in proper proportion and makes it possible to observe where we have advanced, where not, and where, perhaps, we have even retrogressed. It thus can suggest new areas for experimentation.

When we examine recent progress in cloth-making, we come to the curious realization that the momentous development we find is limited to a closely defined area . . . the creation of new fibers and finishes. While the process of weaving has remained virtually unchanged for uncounted centuries, textile chemistry has brought about far-reaching changes, greater changes perhaps than even those brought about through the fast advance in the mechanics of textile production during the last century. We find the core of textile work, the technique of weaving, hardly touched by our modern age, while swift progress in the wider area has acutely affected the quality as much as the quantity of our fabrics. In fact, while a development around the center has taken place, methods of weaving have not only been neglected, but some have even been forgotten in the course of time.

It is easy to visualize how intrigued, as much as mystified, a weaver of ancient Peru would be in looking over the textiles of our day. Having been exposed to the greatest culture in the history of textiles and having been himself a contributor to it, he can be considered a fair judge of our achievements. He would marvel, we can imagine, at the speed of mass production, at the uniformity of threads, the accuracy of the weaving, and the low price. He would enjoy the new yarns used . . . rayon, nylon, aralac, Dacron, Orlon, Dynel, and Fiberglas, to name some of the most important ones.* He

* According to Fairchild's *Dictionary of Textiles*, aralac is an obsolete casein fiber made just prior to and during World War II. Definition supplied by Sarah Lowengard, textile conservator.

would admire the materials that are glazed or water-repellent, crease-resistant, permanent-pleated, or flame-retarding, mothproof, or shrinkage-controlled, and those made fluorescent . . . all results of our new finishes. Even our traditionally used fabrics take on new properties when treated with them. He would learn with amazement of the physical, as well as of the chemical methods of treating fabrics, which give them their tensile strength or their reaction to alkalis or acids, etc. Though our Peruvian critic is accustomed to a large scale of colors, he may be surprised to see new nuances and often a brilliance hitherto unknown to him, as well as a quantitative use of color surpassing anything he had imagined.

The wonder of this new world of textiles may make our ancient expert feel very humble and may even induce him to consider changing his craft and taking up chemistry or mechanical engineering. These are the two major influences in this great development, the one affecting the quality of the working material, and the other the technique of production. But strangely enough, he may find that neither one would serve him in his specific interest: the intricate interlocking of two sets of threads at right angles—weaving.

Concentrating his attention now on this particular phase of textile work, he would have a good chance of regaining his self-confidence. A strange monotony would strike him and puzzle him, we imagine, as he looked at millions of yards of fabric woven in the simplest technique. In most cases, he would recognize at one glance the principle of construction, and he would even find most of the more complex weaves familiar to him. In his search for inventiveness in weaving techniques, he would find few, if any, examples to fascinate him. He himself would feel that he had many suggestions to offer.

An impartial critic of our present civilization would attribute this barrenness in today's weaving to a number of factors. He would point out that an age of machines, substituting more and more mechanisms for handwork, limits in the same measure the versatility of work. He would explain that the process of forming has been disturbed by divorcing the planning from the making, since a product today is in the

hands of many, no longer in the hands of one. Each member of the production line adds mechanically his share to its formation according to a plan beyond his control. Thus the spontaneous shaping of a material has been lost, and the blueprint has taken over. A design on paper, however, cannot take into account the fine surprises of a material and make imaginative use of them. Our critic would point out that this age promotes quantitative standards of value. Durability of materials, consequently, no longer constitutes a value per se and elaborate workmanship is no longer an immediate source of pleasure. Our critic would show that a division between art and craft, or between fine art and manufacture, has taken place under mechanical forms of production; the one carrying almost entirely spiritual and emotional values, the other predominantly practical ones. It is therefore logical that the new development should clarify the role of usefulness in the making of useful objects, paralleling the development of art, which in its process of clarification has divested itself of a literary by-content and has become abstract.

Though the weight of attention is now given to practical forms purged of elements belonging to other modes of thought, aesthetic qualities nevertheless are present naturally and inconspicuously. Avoiding decorative additions, our fabrics today are often beautiful, so we believe, through the clear use of the raw material, bringing out its inherent qualities. Since even solid colors might be seen as an aesthetic appendage, hiding the characteristics of a material, we often prefer fabrics in natural, undyed tones.

Our new synthetic fibers, derived from such different sources as coal, casein, soybeans, seaweed, or lime, have multiplied many times the number of our traditionally used fibers. Our materials therefore, even when woven in the simplest techniques, are widely varied in quality, and the number of variations are still increased through the effects of the new finishes. Yards and yards of plain and useful material, therefore, do not bore us. Rather they give us a unique satisfaction. To a member of an earlier civilization, such as our Peruvian, these materials would be lacking in those qualities that would make them meaningful to him or beautiful.

Though we have succeeded in achieving a great variety of fabrics without much variation of weaving technique, the vast field of weaving itself is open today for experimentation. At present, our industry has no laboratories for such work. (Today, 1959, the situation is changing.) The test tube and the slide rule have, so far, taken good care of our progress. Nevertheless, the art of building a fabric out of threads is still a primary concern to some weavers, and thus experimenting has continued. Though not in general admitted to the officialdom of industrial production, some hand-weavers have been trying to draw attention to weaving itself as an integral part of textile work.

At their looms, free from the dictates of a blueprint, these weavers are bringing back the qualities that result from an immediate relation of the working material and the work process. Their fresh and discerning attempts to use surface qualities of weaves are resulting in a new school of textile design. It is largely due to their work that textures are again becoming an element of interest. Texture effects belong to the very structure of the material and are not superimposed decorative patterns, which at present have lost our love. Surface treatment of weaving, however, can become as much an ornamental addition as any pattern by an overuse of the qualities that are organically part of the fabric structure.

Though it is through the stimulating influence of hand-weaving that the industry is becoming aware of some new textile possibilities, not all hand-weaving today has contributed to it. To have positive results, a work that leads away from the general trend of a period has to overcome certain perplexities. There is a danger of isolationism . . . hand-weavers withdrawing from contemporary problems and burying themselves in weaving recipe books of the past; there is a resentment of an industrial present, which due to a superior technique of manufacture, bypasses them; there is a romantic overestimation of handwork in contrast to machine work and a belief in artificial preservation of a market that is no longer of vital importance.

Crafts have a place today beyond that of a backwoods subsidy or as a therapeutic means. Any craft is potentially art, and as such not under discussion here. Crafts

Textile sample, ca. 1945.
Cellophane and jute, 91 × 101.5 cms (35 7/8 × 40 ins).
The Metropolitan Museum of Art, Gift of Anni Albers, 1970.
© 1998 By The Metropolitan Museum of Art. 1970.75.9

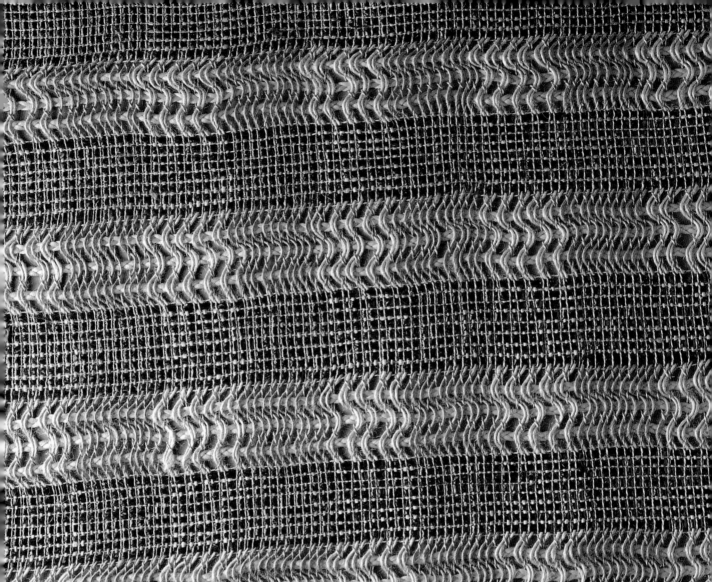

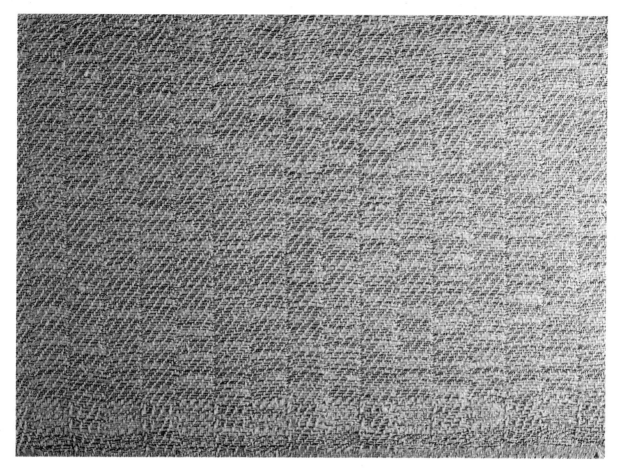

Textile sample, ca. 1946.
Cotton, linen, metal foil, 34 × 45 cms (13 3/8 × 17 3/4 ins).
The Metropolitan Museum of Art, Gift of Anni Albers, 1970.
© 1998 By The Metropolitan Museum of Art . 1970.75.18

Opposite:
Partition material, ca.1949.
Cotton, jute, horsehair, cellophane, 151 × 85 cms (59 3/8 × 33 1/2 ins).
The Metropolitan Museum of Art, Gift of Anni Albers, 1970.
© 1998 By The Metropolitan Museum of Art. 1970.75.12

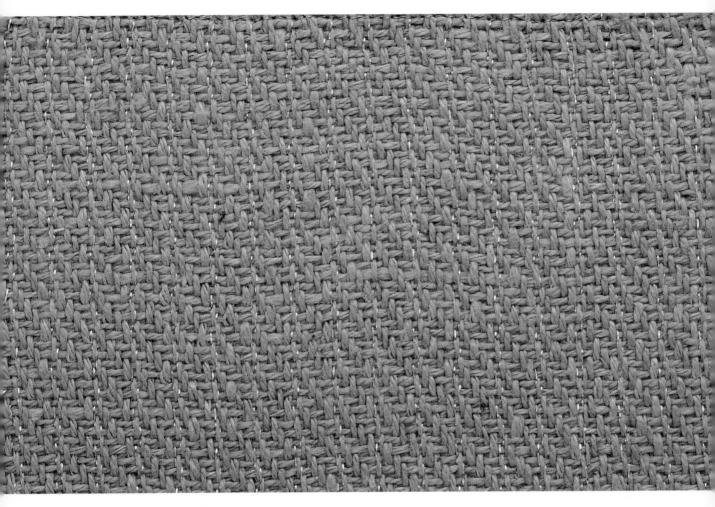

Textile sample, probably after 1933.
Cotton and rayon, 15.2 × 20.3 cms (6 × 8 ins).
The Museum of Modern Art, New York, Gift of Josef Albers.
Photograph © 2000 By The Museum of Modern Art, New York. 450.70.60

Opposite:
Textile sample, ca. 1948.
Fiberglass, 19 × 15 cms (7$^{1}/_{2}$ × 5$^{7}/_{8}$ ins).
The Metropolitan Museum of Art, Gift of Anni Albers, 1970.
© 1998 By The Metropolitan Museum of Art. 1970.75.59

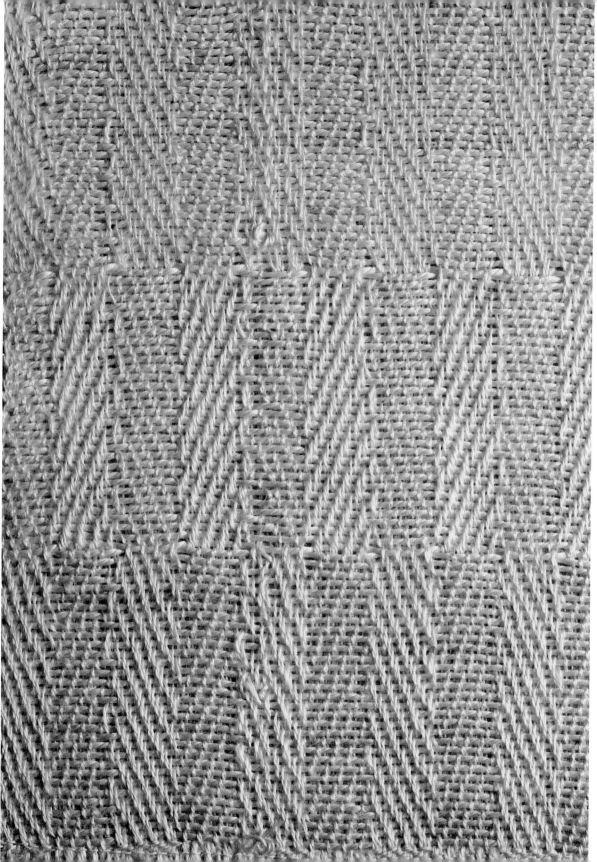

Textile sample, probably after 1933. Cellophane and cotton, 22.5 × 18.5 cms (8$^{7}/_{8}$ × 7$^{1}/_{4}$ ins). The Metropolitan Museum of Art, Gift of Anni Albers, 1970. © 1998 By The Metropolitan Museum of Art. 1970.75.57

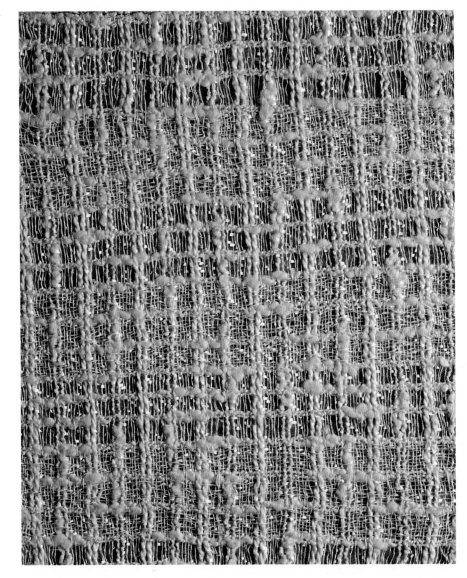

Opposite:
Textile sample.
Cellophane and cotton, 20 × 19 cms (7$^{7}/_{8}$ × 7$^{1}/_{2}$ ins).
The Metropolitan Museum of Art, Gift of Anni Albers, 1970.
© 1998 By The Metropolitan Museum of Art. 1970.75.56

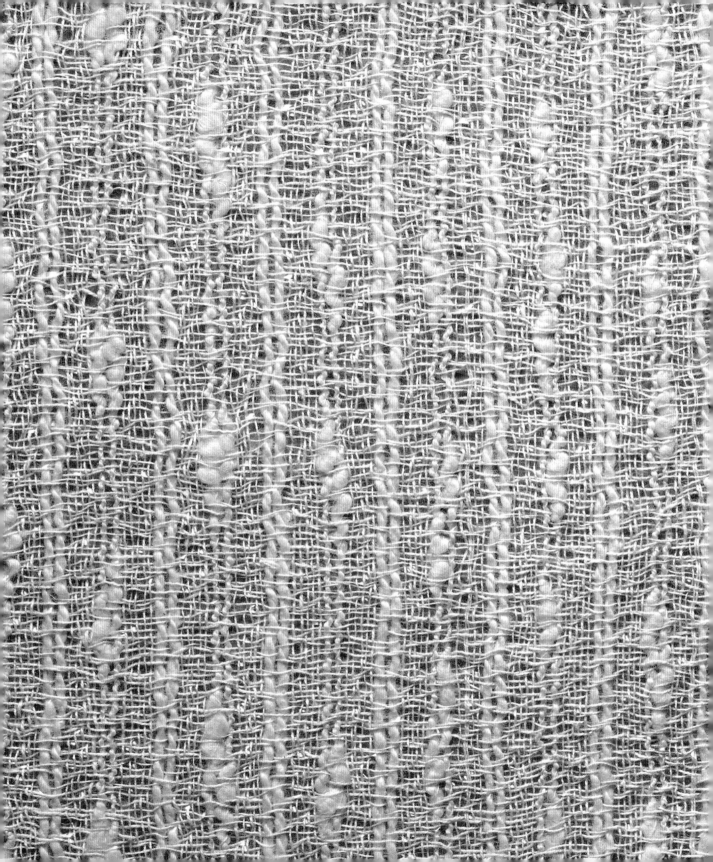

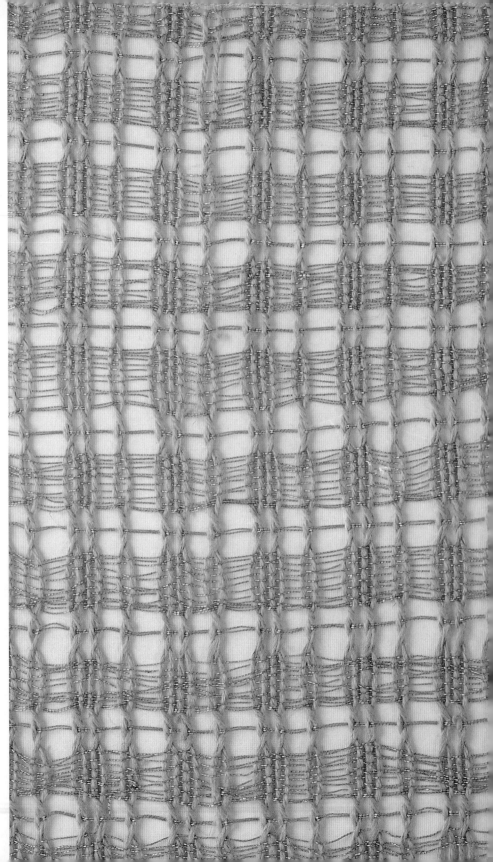

Woven fabric sample, ca. 1951. Linen and metallic thread, 27.9 × 15.9 cms (11 × 6¼ ins). The Museum of Modern Art, New York. Gift of Josef Albers. Photograph © 2000 By The Museum of Modern Art, New York. 450.70.79

become problematic when they are hybrids of art and usefulness (once a natural union), not quite reaching the level of art and not quite that of clearly defined usefulness. An example is our present-day ashtray art . . . trash.

Modern industry is the new form of the old crafts, and both industry and the crafts should remember their genealogical relation. Instead of a feud, they should have a family reunion. Since the craft of weaving is making, in an unauthorized manner, its contribution to the new development and is beginning to draw attention to itself, we can look forward to the time when it will be accepted as a vital part of the industrial process.

The influence that hand-weaving has had thus far has been mainly in the treatment of the appearance, the epidermis, of fabrics. The engineering work of fabric construction, which affects the fundamental characteristics of a material, has barely been considered. It is probably again the task of hand-weavers to work in this direction. For just as silk, a soft material by nature, can become stiff in the form of taffeta, through a certain thread construction, and linen, a comparatively stiff material, can be made soft in another, so an endless number of constructional effects can produce new fabrics. The increasing number of new fibers incorporating new qualities creates a special challenge to try the effects of construction on them. Just as chemical treatment has produced fluorescence, so structural treatment can produce, for example, sound-absorption. Our ancient Peruvian colleague might lose his puzzled expression, seeing us thus set for adventures with threads, adventures that we suspect had been his passion.

Industry should take time off for these experiments in textile construction and, as the easiest practicable solution, incorporate hand-weavers as laboratory workers in its scheme. By including the weaver's imaginative and constructive inventiveness, as well as his hand-loom with its wide operational scope, progress in textile work may grow from progress in part to a really balanced progress.

1946 (revised 1959)

Though only the few penetrate the screen that habits of thought and conduct form in their time, it is good for all of us to pause sometimes, to think, wonder, and maybe worry; to ask "where are we now? "

Concerned with form and with the shape of objects surrounding us—that is, with design—we will have to look at the things we have made. With the evidence of our work before us, we cannot escape its verdict. Today it tells us of separateness, of segregation and fragmentation, if I interpret rightly. For here we find two distinct points of departure: the scientific and technological, and the artistic. Too often these approaches arrive at separate results instead of at a single, all-inclusive form that embodies the whole of our needs: the need for the functioning of a thing and the need for an appearance that responds to our sense of form.

This complete form is not the mixture of functional form with decoration, ornament, or an extravagant shape; it is the coalition of form answering practical needs and form answering aesthetic needs. Yet wherever we look today we are surrounded by objects which answer one or the other of these demands and only rarely both. If we believe that the visual influences us we must conclude that we are continually adding to disunity instead of to wholeness, that we are passing on the disunity which brought our objects about.

Wholeness is not a Utopian dream. It is something that we once possessed and now seem largely to have lost, or to say it less pessimistically, seem to have lost were it not for our inner sense of direction which still reminds us that something is wrong here because we know of something that is right.

An ancient Greek vase, though unsuited to any use today, still fills us with awe. We accept it as a manifestation of completeness, of true perfection. A bucket, fulfilling today somewhat the same purpose and functionally far superior to the ancient vessel,

embarrasses us and we would blush were our cultural standards to be judged by it. We sense its incompleteness. It is true that some of our technical products today, our chemical glass or china, for instance, or some of the work of engineering, exhibit, in addition to—or by reason of—their clearly defined function, a rare purity of form; they are beautiful. But of the many things that make up our equipment today, hardly any are pure in form though perhaps sufficiently useful. On the other hand, those of our objects which are more concerned with the artistic, the products of our crafts, often are found lacking technologically and are often, if at all, only in part representative of our time.

Though fundamentally, people seem to change very little in the course of centuries, we of today are obliged to approach this work of designing very differently from our predecessors. If we realize that designing is more than merely giving a final outer appearance to articles of use, our problem becomes obvious. The craftsman, the designer of old, usually did not find his raw material ready-made, waiting to be put to use by him; he had to prepare it himself. Nor did he follow a prescribed course of handling his material, but often himself was the inventor of working methods. At the same time he was the artist, free to use his material to his end in whatever way he would feel impelled to use it. The characteristics of the material or the working procedure may have intrigued him, or the use his product was meant to be put to, or any other stimulus or their combination that may excite an artist. Picasso writes: "The artist is a receptacle for emotions, regardless of whether they spring from heaven, from earth, from a scrap of paper, from a passing face, or from a spider's web."

In our modern world this all-comprising work of the craftsman is broken up into separate functions. The task of supplying the raw material is largely in the hands of science. Science not only supplies us with new processes of treating the products of nature as we have known them, but, changing the structure of materials, creates new compounds. The properties of known materials can be transformed, giving them new qualities. New materials have been brought to us, often characterized by their amazing pliability, their lack of rigidity. Today, the task of determining the working

processes is in the hands of technologists and engineers; the execution of the work is in the hands of workmen, each one of them responsible only for a segment of the work. The planning of the shape of the thing to be? Here we have reached the crucial point.

We may think of "design" as the form we give to things after consideration of the varied and many claims from which that form evolves. There are the claims made by the purpose of the object as to choice of working material, further claims in regard to treatment that the chosen materials make, and claims which develop with procedure of work. We must also regard as cogent those considerations that come up with marketing, both financial and psychological, that is, those dealing with an imaginary or future public. Trends are important considerations whether in regard to function or appearance, including the trends that come into view and those that should be brought about. Obligations arise with exerting influence by the very act of adding more objects to this already complicated world. Finally, if we regard the culmination, the subtle effects of those intangible qualities that lie in proportion, in color, in surface treatment, in size, in the relationship of all factors together which constitute FORM—all of this enters into what we consider "design," then the problems of designing today, I think, become apparent.

The craftsman held together in his work all these varied aspects of forming. He was the coordinator of all the forces affecting his product. He had the material in hand, not only figuratively, but actually, and it was his actual experience of wood, of fiber, of metal, that told him about his material. Its strength and its weakness directed him. His tools, too, were in his hands and they led the way, circumscribing the range of action. His output answered first of all the demand of his own community, a public known to him through direct contact, and its response directed him—approving, suggesting, disapproving. His production was on a scale that allowed for changes and, if it proved unsuccessful, financial risk could be kept under control. His independence as the sole in command, his not being tied to any outlined routine of production, allowed for formative speculation and imaginative variation from piece to piece and

thus for improvement. (This chance for progress from one piece to the other is important to the conscientious worker.) Above all, the craftsman was free to follow the promptings of material, of color, line, texture; to pursue a thoughtful forecast of function, a cleverly conceived construction, to wherever it would lead him. The results were objects embodying the many forces that took part in their making; some so finely blended that this whole became art, others, less successfully, the fertile soil for art.

Today we have a different scene. The many considerations that go into this entity called FORM are, of course, the same. But the miraculous event that is changed from addition to sum—the fusion of parts into one whole—is indeed a rare event. No one organizer is any longer at work. A staff of specialists, sectional professionals, has taken the craftsman's place. (With expanding knowledge goes limitation in range.) The product of contributions from scientist, engineer, financier, market analyst, production manager, sales manager, workman, artist is the addition of these many factors; to form from the parts a whole takes a spirit of great cooperation. Too often though, the parts compete, each seeking to predominate and, subsequently, we have not wholeness but fragmentation. A cathedral, of course, was also not one man's work; but a common belief guided all efforts and acted as coordinator where today we seem largely lacking in an overall purpose.

Division of work is not the only aspect of specialization. Specialization means the loss of direct, actual experience beyond the field of specialty and there substitutes information for experience. But information means intellectualization and intellectualization—one-sidedness, incompleteness. Alfred North Whitehead comes to my aid here when he says:

Effective knowledge is professionalized knowledge, supported by a restricted acquaintance with useful subjects subservient to it.

This situation has its dangers. It produces minds in a groove. Each profession makes progress, but it is progress in its own groove. Now to be mentally in a groove

is to live in contemplating a given set of abstractions. The groove prevents straying across country, and the abstraction abstracts from something to which no further attention is paid. But there is no groove of abstractions which is adequate for the comprehension of human life. Thus in the modern world the celibacy of the medieval learned class has been replaced by a celibacy of the intellect which is divorced from the concrete contemplation of the complete facts. Of course, no one is merely a mathematician, or merely a lawyer. People have lives outside their professions or their businesses. But the point is the restraint of serious thought within a groove. The remainder of life is treated superficially, within the imperfect categories of thought derived from one profession.

The dangers arising from this aspect of professionalism are great, particularly in our democratic societies. The directive force of reason is weakened. The leading intellects lack balance.

Designing has become more and more an intellectual performance, the organization of the constituent parts into a coalition, parts whose function is comprehended but can no longer be immediately experienced. Designing today is indirect forming. It deals no longer directly with the medium but vicariously: graphically and verbally.

To restore to the designer the experience of *direct* experience of a medium is, I think, the task today. Here is, as I see it, a justification for crafts today. For it means taking, for instance, the working material into the hand, learning by working it of its obedience and its resistance, its potency and its weakness, its charm and dullness. The material itself is full of suggestions for its use if we approach it unaggressively, receptively. It is a source of unending stimulation and advises us in most unexpected manner.

Design is often regarded as the form imposed on the material by the designer. But if we, as designers, cooperate with the material, treat it democratically, you might say, we will reach a less subjective solution of this problem of form and therefore a more inclusive and permanent one. The less we, as designers, exhibit in our work

our personal traits, our likes and dislikes, our peculiarities and idiosyncrasies, in short, our individuality, the more balanced the form we arrive at will be. It is better that the material speaks than that we speak ourselves. The design that shouts, "I am a product of Mr. X," is a bad design. As consumers, we are not interested in Mr. X but in his product, which we want to be our servant and not his personal ambassador. Now, if we sit at our desk designing, we cannot avoid exhibiting ourselves for we are excluding the material as our co-worker, as the directive force in our planning.

The good designer is the anonymous designer, so I believe, the one who does not stand in the way of the material; who sends his products on their way to a useful life without an ambitious appearance. A useful object should perform its duty without much ado. The tablecloth that calls, "Here I am, look at me," is invading the privacy of the consumer. The curtains that cry, "We are beautiful, your attention please," but whisper, "though not very practical, we will need much of your time to keep us in shape," are badly designed. The unknown designer or designers of our sheets or of our lightbulbs performed their task well. Their products are complete in their unpretentious form.

The more we avoid standing in the way of the material and in the way of tools and machines, the better chance there is that our work will not be dated, will not bear the stamp of too limited a period of time and be old-fashioned someday instead of antique. The imprint of a time is unavoidable. It will occur without our purposely fashioning it. And it will outlast fashions only if it embodies lasting, together with transitory, qualities.

Not only the materials themselves, which we come to know in a craft, are our teachers. The tools, or the more mechanized tools, our machines, are our guides, too. We learn from them of the interaction of material and its use, how a material can change its character when used in a certain construction and how in turn the construction is affected by the material; how we can support the characteristics of material or suppress them, depending on the form of construction we use. In architecture this may mean the difference of roman and gothic style, in weaving the same difference on a

minute scale, the difference of satin and taffeta—the same material in different con-struction. Important, too, is the realization that with the increased perfection of a tool in regard to any one function, its range of use grows more limited. Thus we find that for a hand-weaver, for instance, the foot-power loom allows for far greater variety of work than a machine loom for "each step towards the mechanical perfection of the loom, in common with all machines, in its degree, lessens the freedom of the weaver, and his control of the design in working," says Luther Hooper.*

In regard to material and tools or machines, it may be easier to supply the direct experience of their influence on the form of the object to be, than to supply the expe-rience of the public demand and public reaction. The buyer, who today is the inter-preter of public taste, only rarely has the necessary penetrating insight or foresight for this influential task. Were the judgment of the buyer of any consideration to the pro-duction and exhibition of a work of art, for instance, the event of a Paul Klee or a Pi-casso would have been utterly impossible. The public has more good sense and sound judgment than is usually supposed. The buyer has an inclination to base his estimation on the expression of lower rather than on higher tastes. He also may be misled in his interpretations by the deflecting influence of advertising. If the public were given a free chance to choose a larger number of well-designed objects, it would perhaps rise above any now-expected response. The designer of today who is asked to consider this forecast of public reaction is dealing possibly with a fictitious public, a public that is known to him only by hearsay. He may be adjusting his product to the unreal public that a biased interpreter is showing him. The craftsman of old was in the fortunate position to know his public in the circle of his immediate neighbors. Even though this group may not have included all of his customers, he could check public response by direct contact with this part of his public. A tentative production by the method of craft, on a small scale, might make it possible to try out an object

* Luther Hooper, *Hand-loom Weaving, Plain and Ornamental* (London and New York: Sir I. Pitman & Sons, Ltd., 1920).

and gather public reaction to it before it is produced on the enormous scale of today's mass production. Maybe it would then be possible to avoid speculation as to the acceptance of an article and have a more reliable basis for judging public response. Perhaps it would then also be possible to be bolder in our production and not necessarily conform so much to questionable standards. This may be less impractical than it seems for it might make it possible to avoid large scale financial risk. All these practical considerations, real, or fictitious, such as those in regard to a general acceptance, may act, as we have seen, as a stimulus to the designer. On the other hand, these very considerations may, at times, be frustrating to him and may impede the full play of his inventiveness, his freedom as an artist. When the practical usefulness of the object to be threatens to turn mainly into constraint, his conscience as artist may tell him to disregard it in favor of unrestricted use of color, line, texture, or whatever other form-element may be leading him on. Losing sight of the practical purpose need not necessarily be a loss, for the impractical result may turn out to be — art.

1947

REVIEW OF BEN NICHOLSON'S
PAINTINGS, RELIEFS, DRAWINGS

This publication, supervised and laid out by the artist himself, is all an artist could desire as a record of his work.* It should also be of interest to those concerned with the work of their contemporaries.

The book is a carefully prepared document of the work of the painter who represents the avant-garde in Great Britain. Herbert Read's masterful analysis of today's tendencies in art, of abstract art as contrasted to vital art, is based on Wilhelm Worringer's celebrated essay *Abstraktion und Einfühlung* (Abstraction and Empathy) written in 1906 and published two years later. It introduces the reader to two fundamentally different psychological attitudes, that of a feeling of fear and separation in the face of nature and that of delight. In the formative process the one will result in a tendency to abstraction, the other to naturalism. Read quotes at length Worringer's text as transcribed by T. E. Hulme. He uses this brilliant essay to create a basis from which the perhaps contradictory phenomenon of Nicholson's work can be explained, the uniting in his work of both tendencies alternately if not in concert. Read observes that Worringer as well as Hulme recognized the coexistence of both tendencies in past epochs. But in the past such occurrence was the expression of certain groups. "What we must affirm now is the possibility not merely of an individual reaction, but even the alternation within the individual consciousness, of both attitudes," suggests Read as the crux of his argument. "In certain cases it seems possible for an individual to alternate between the extremes represented by this polarity—to tend in one psychological phase towards an affirmation of the world which results in a naturalistic style, and in another psychological phase to tend towards a rejection of that world

* Ben Nicholson, *Paintings, Reliefs, Drawings*, with an introduction by Herbert Read (London: Lund Humphries, 1948).

which results in an abstract style of art. Ben Nicholson is an artist of this complex type." One could not wish for a more skillful expounder of complexities than Read.

There are broad statements of general truth in this introduction, though perhaps to the argument that "Art is a subjective process of individuation" the opposite statement could be made, that art is the process of arriving at a form that comprises a generic rather than the initial individual experience.

The book contains notes on abstract art by the artist himself. Though it is obvious that his proper medium of expression is that of the painter and sculptor, these notes give insight into the process of his orientation. His pictures and reliefs seem to be far clearer in formulation. They show in every work great refinement and conclusiveness of presentation. Perhaps they lack the grandeur and austerity of pioneer work, but their sensitivity and perfection of performance make them important works of art. In Read's words, "The work of Ben Nicholson is peculiarly significant in that with relatively simple and direct means it produces the intensest vibrations of the aesthetic sensibility." The two hundred plates of the book (forty in color) and the statement on art in our time and on the artist specifically, all make the book an important testimonial of today.

1950

THE PLIABLE PLANE: TEXTILES IN ARCHITECTURE

If the nature of architecture is the grounded, the fixed, the permanent, then textiles are its very antithesis. If, however, we think of the process of building and the process of weaving and compare the work involved, we will find similarities despite the vast difference in scale. Both construct a whole from separate parts that retain their identity, a manner of proceeding fundamentally different from that of working metal, for instance, or clay, where parts are absorbed into an entity. This basic difference, however, has grown less clearly defined as new methods are developing, affecting both building and weaving, and are adding increasingly to fusion as opposed to linkage.

Both are ancient crafts, older even than pottery or metalwork. In early stages they had in common the purpose of providing shelter, one for a settled life, the other for a life of wandering, a nomadic life. To this day they are characterized by the traits that made them suited to these two different tasks, obvious in the case of building, obscured, more or less, in that of textiles. Since the obvious hardly needs to be examined, let us turn to the less evident.

When we move about, we carry with us, above all else, the clothes we wear and these have always been of material, textile in its nature, if not actually a textile. We can recognize in leaves and bark, and especially in hides and furs, prototypes of fabric and it is their use as our secondary skin, either in their paleolithic or their transposed form, that has made us independent of place, hour, and season, in the remote past as today.

In our early history, such independence surely brought on a further immediate need, that for a transportable shelter. The same type of material which proved so suited for clothing was also appropriate here, a material that was pliable above all other characteristics and therefore easily portable. Hides stretched over poles were an

efficient solution for this problem of shelter, for such a material, when expanded, could shed water, hold off the wind, and give shade. In transit it could be folded; that is, reduced to a fraction of its extended size: the minimum tent.

In a life of wandering, not only *what* is carried has to be portable, but the *means* for carrying things have to be found and developed. A string that holds a bundle together, or a group of strings forming a net or bag, are direct ancestors to our air-luggage today. The textile material, pliable and lightweight, is of utmost efficiency in transit. It is interesting to observe that our carrying cases with a need for decreasing weight in fast travel are becoming again more and more a mere bag of cloth. But from a string or a connected group of strings to a fabric, a long history of inventions passed. In distant history it may well have been the use of hides that challenged the inventive minds to fabricate a counterpart. Through thousands of years of textile experimentation, however, nature's remarkable model still stands unsurpassed in many of its practical aspects. But in the course of development the resulting "fabrics" have taken on characteristics that belong to them alone and which, in turn, perform in various ways better than the original example supplied by nature.

Initial attempts must have been concerned mainly with thread construction. In fact, excavations in the last decade in northern Peru brought to light innumerable small pieces of cloth that seem useless in their limited size unless understood as structural experiments. The earliest specimens show textile techniques other than weaving, but gradually weaving evolved and finally took over. It is interesting in this connection to observe that in ancient myths from many parts of the world it was a goddess, a female deity, who brought the invention of weaving to mankind. When we realize that weaving is primarily a process of structural organization this thought is startling, for today thinking in terms of structure seems closer to the inclination of men than women. A reason may have been that men as hunters supplied the skins of animals and that women as gatherers had pass through their hands, along with berries and roots, textile raw material in the form of reeds, vines, and grasses. Later, with weaving traditions established, embellishing as one of the

weaver's tasks moved to the foreground and thus the feminine role in it has become natural in our eyes. Regardless of speculation as to origin, we know that it has taken generation after generation to perfect a method of interlacing threads that has proved in the course of time so potent in possibilities. What we should bear in mind here is the specific quality of textiles in regard to flexibility, pliability, and their high degree of performance relative to their weight, before taking up the part they play aesthetically.

From the first shelter of hides to the latest tent for camping, in peace as in war, the idea of a transportable and therefore lightweight house has remained essentially the same. The walls are of nonrigid, nonsupporting material, a material of textile character if not a textile itself, a material that can easily be fastened to supports. Wherever provisional quarters have to be built speedily and independent of local material, the textile house, the tent, is the answer because of the inherent characteristic of cloth that one might call its nomadic nature. (The felt-lined tents, the yurts, used as houses in Outer Mongolia, can be dismantled in fifteen minutes, so the *New York Times* of October 21, 1956 reports.)

Shelter is perhaps the most vital use, besides clothing, that has been made of this pliable, quasi two-dimensional material. This two-dimensionality has played a major part in the making of textiles. Length never created a serious problem, while width on the other hand had to be solved by various inventions. Thinness of fabric, linked with lightness, is still a concern of weavers.

A further quality of cloth or of its antecedents should be added to our list: its ability to keep us warm, its nonconducting quality. Insulation is one of the performances of fabrics that is clearly apparent in clothing.

If a first need for textiles came with a need for clothing and shelter, the use of these textiles changed with changing needs, with the development of needs. Though they still protect us today against the weather in the form of clothes in our regular settled form of life, they no longer provide us with shelter except in our spells of nomadism, as tourists or warriors. With the discontinuance of this one major function textiles

moved indoors, inside our habitations. If we recall the attributes we have given them: insulating, pliable, transportable, relatively lightweight, all of these have been and still are active, as they were outdoors, in the interiors of houses all over the world throughout the centuries. But with their relaxed duties, that is, no longer having to guard our life, they have accumulated more and more functions that belong to another realm—aesthetic functions. These, in time, have moved so much to the foreground that today "decoration" has become for many the first and sometimes only reason for using fabrics. In "decoration" we have an additive that we may well look at, if not skeptically, at least questioningly.

We can surmise that perhaps a parallel development, however faint, can be found in regard to clothing. We still, in certain climates and at certain seasons, need clothes as urgently as did our early ancestors. But with a sedentary life, with permanent, warm shelters, clothing is no longer a twenty-four-hour problem in any weather. We dress indoors for other reasons than solely as protection against the cold or heat. That we dress for aesthetic reasons, among others, has been proved with the first pretty fig leaf. Perhaps we even can say that part of our protective covering has moved indoors if we look at our bed with its sheets and blankets as a sort of clothing extension.

In general then, except for some of our clothes, textiles have taken on an indoor existence. Their protective duties have changed. Instead of keeping off the wind, they now may keep the sun from inside the house and, important today in a crowded world, protect the privacy of the inhabitants. They still give warmth, on floors for instance, and may give insulation from drafts as curtains—functions losing importance with improved building conditions. On the other hand they are taking on new tasks like sound-absorption, a problem growing with a noisier world. In fact, we ask of our fabrics more diversified services than ever before. Today we may want them to be light-reflecting, even fluorescent, crease-resistant, or permanently pleated and have such invisible qualities as being water-repellent, fast-drying, nonshrinking, dust-shedding, spot-resistant, and mildew-proof, to name only a few. We are witnessing

today an acceleration of textile progress not even remotely resembling any other in history. Strangely, advances are not due to any improvements in weaving itself, that is, to new inventions of thread interlacing. Here we can actually see a regression. The impressive textile development at present is almost entirely due to new chemical processes that bring us new fibers and finishes. In constant succession we find announcements of new textile materials and treatments that "-ize" our fabrics, from the already classic "Sanforize" to a surprising "sanitize"—self-explanatory—to an occasional absurdity such as "heavenize" riding the wave of the day's "-ize" promises.

But though these new qualities, often not visually apparent, show where the concentration of present textile progress lies, the traditional, visual qualities usually carry greater weight in the mind of the public, at least when concerned with settled life. A fabric is largely chosen because it is red, for instance, and often regardless of whether equipped with other virtues, in preference to one more sensibly endowed for a specific situation but lacking such instantaneous, visual appeal as that of color.

When we revert to nomadism, however, as travelers, we are open to textile behavior as were our distant forebears, with this difference, that the dominant, mobile quality of fabrics through usage in thousands of years is lost in general to our awareness, while we seek eagerly newly acquired features, suited to our speed of travel. One dacron-cotton shirt, fast-drying, absorbent and shape-retaining, may take us around the world.

In our settled existence the character of mobility in our fabrics is nevertheless manifest: as curtains they are drawn open or closed, letting in light or shutting it out, thereby changing dramatically the appearance of a room. As table mats or tablecloths they are put on and taken off again; as bedspreads they are removed at night. They can be lifted, folded, carried, stored away, and exchanged easily; thus they bring a refreshing element of change into the now immobile house. The very fact of mobility makes them the carrier of extra aesthetic values. A red wall may become threatening in the constancy of a high pitch, while red curtains of equal color intensity and able to cover an equal area can be of great vitality and yet not overpowering because the red

area can be varied by drawing the curtain. The perishable nature of fabrics, though in many respects a severe disadvantage, turns into an advantage when a red fabric can be replaced by a blue one for instance, more easily than is possible with most other materials. Their perishability is often a welcome reason for change. That color, texture, draping quality, gloss or dullness, etc. have become dominant as aesthetic components is a logical development. That we also overdo our textile furnishings today in many instances is a residue, it seems, from *temps perdus*, from periods in architecture less efficient than ours in providing controlled temperature.

Let us look closer. Let us assume someone is moving into quarters that today have those wires, pipes, buttons, etc. that serve to light and heat, supply with water or drain, cool, and ventilate a place. Let us suppose that blinds at the windows regulate the light by day and guard the privacy by night. In short let us visualize it as ready to live in, once beds, chairs, and tables, essentials to our Western mind, have been moved in; a place that obviously can function virtually without textiles. Nevertheless, without them there will be a feeling of barrenness, even coldness, that can be justified in part and partly perhaps is no more than a matter of convention. What is missing through the lack of fabrics is presumably something that is warm to the touch, quite possibly color, the soft play of folds, and the luster or fuzz of fibers in contrast to flat, hard, and cool surfaces. On the floor, or on sections of it, we may miss a soft, sound-subduing, and warming covering, a carpet or rug, and at the windows a light veil to keep out any glare and add to further privacy.

If today, we would go about the task of choosing fabrics guided by a clear head before we become engrossed in the spontaneous pleasures that color, surface, and the "hand" of cloth give us, our rooms would look uncluttered, spacious, and serene. They would look animated by those qualities of materials that we know so intimately from wearing them: from their use next to our skin. And if we think of clothing as a secondary skin we might enlarge on this thought and realize that the enclosure of walls in a way is a third covering, that our habitation is another "habit."

It is not abundance or sparsity of fabrics, though, that may date our interiors. It is

as much the way our fabrics are used. Today we have no time for frills: we hang our curtains from ceiling to floor in straight folds. Instead of decorative additaments they thus become an integral architectural element, a counterpart to solid walls. Mies van der Rohe was one of the first to use them in this architectural form. Le Corbusier, in a different way, incorporates textiles into an architectural scheme, using them as enormous flat wall-panels, banners, that carry color and form and serve perhaps also as sound-absorbing flats. Above all they become a focal point, as in the halls of his Indian High Court of Justice at Chandigarh.

This is not an altogether new use. Large tapestries have for centuries been used as pictorial walls and rugs as pictorial floors, warming but principally centralizing our attention. A beautiful view, the flickering of a fire, the play of water, flowers, all serve as such a focal point. If man-made, it is only art that is able to hold our interest any length of time. There seems to be no real place today for "almost art," for embellishment and for ornamentation: the elaborated detail. Perhaps it is the restlessness of our manner of Western living that has to be achieved by a planned simplicity, a strong subordination of details to the overall conception of an architectural plan. When we decorate we detract and distract.

Textiles themselves have responded to a large degree to this keynote of calm by showing, instead of mainly patterns, overall textural designs and solid colors. By introducing materials suited to partitioning sections of interiors, they have contributed specifically to impressions of spaciousness and lightness in our living areas, that is, to tranquillity. Fabrics, however, could be incorporated into the interior planning far beyond an occasional partition. A museum, to give a large-scale example, could set up textile panels instead of rigid ones to provide for the many subdivisions and backgrounds it needs. Such fabric walls could have varying degrees of transparency or be opaque, even light-reflecting. They could be interchanged easily with changing needs and would bring an intensified note of airiness to a place. In ancient Japanese houses veil-like fabric panels were used to form rooms and to allow the breeze to pass through. (The Japanese movie *Gate of Hell* shows such use in early times.)

The essentially structural principles that relate the work of building and weaving could form the basis of a new understanding between the architect and the inventive weaver. New uses of fabrics and new fabrics could result from a collaboration; and textiles, so often no more than an afterthought in planning, might take a place again as a contributing thought.

September 1957

Whenever I find myself listed as a craftsman or, as here, as an artist-craftsman, I feel that I have to explain myself to myself or occasionally, as here, to others.

For, when taking a rather long look at the past, at what craftsmen made centuries ago—even thousands of years ago—all over the world, I feel an unworthy latecomer, perhaps belonging to an almost obsolete species.

These ancient craftsmen were artists, no hyphen needed. They were of truly vital importance, to the point of being actually responsible for the survival of mankind, in the glacial period for instance, as I see it. The marvelous paintings in caves such as Lascaux, with their precisely observed representations of animals, were not murals as we understand them today. They were not only great art; the indications of arrows on them, to my naive understanding, show that they also served as a sort of textbook for hunters. However, those who know (Herbert Kuhn etc.) interpret these pictures less practically, solely as manifestations of magic rites. So don't trust my additional speculations. But though I certainly believe that art, in another sense, is magic, I like to think that in a remote way I owe my life to those careful artist-teachers who lived so very long ago.

How vital are the crafts to our life today, the life of Western civilization? How conscientious, how careful, how responsible even, are we on the right side of this hyphen? Today's life does not depend on the crafts, we have to admit. In fact, life depends so little on them that they have become to a worrisome degree unresponsive to even minor practical considerations. A while ago I served on a jury where 2,500 objects were submitted, and I confess I still have not recovered from the shock that 2,450 senseless, useless things gave me. Being no longer a vital factor, their standards seem to have become obscured. They belong to a twilight zone, not quite art, not really useful, except—well, the exceptions. And it is about this positive, exceptional side that I want to say a few words.

Today it is the artist who in many instances is continuing the direct work with a material, with a challenging material; and it is here, I believe, that the true craftsman is found—inventive as ever, ingenious, intuitive, skillful, worthy of linking us with the past. His work is concerned with meaningful form, finding significant terms for newly unfolding areas of awareness. And dealing with visual matter, the stuff the world is made of, the inherent discipline of matter acts as a regulative force: not everything "goes." To circumvent the NO of the material with the YES of an inventive solution, that is the way new things come about—in a contest with the material. It is this knowledge that rules are the nature of nature, that chaos is senseless, that is thus transmitted to and through a work that is art.

Now the reason why I am trying to disentangle my thoughts here is that I believe that this direct work with a material, a work that in general no longer belongs to our way of doing things, is one way that might give us back a greater sense of balance, of perspective and proportion in regard to our perhaps too highly rated subjectiveness, projected so often as the theme in those areas of art that are not operating under a resistant material. And to stay within the realm of the visual arts: today a painter can just squeeze a tube and his obedient medium permits him to use it any way he likes—with care, without care, splashing it if he wishes. This outer unrestraint does not provide him with the stimulation and source for inventiveness that may come in the course of struggling with a hard-to-handle material. It rather permits him unrestraint in turn, in every form or formlessness. For many today, introspection then becomes the unfiltered and often the sole source material; and thus convulsion is mistaken for revelation.

A vivid remark, recently, in this direction of unqualified freedom was made by the poet Robert Frost (you may have read it). He says: "I would as soon write free verse as play tennis with the net down."

Also for the hobbyist, this new subspecies of craftsman today, the use of obedient materials, except for reasons of immediate expediency, is of no true help. Little is gained when nothing can be learned about the inherent tidy behavior of matter.

There is, of course, a most legitimate urge in everyone to use his hands, and this takes us back again to earliest periods. For when man learned to go upright, his hands were freed for the making of things, his most human trait, and his mind developed with it. The process from the vague impulse to make something to the final condensation is not served best by limitless freedom but by limitation, by the compelling rules of matter or by self-imposed rules.

The factor of purpose, of practical use, can serve equally as such a condenser: a building is specified, so is a teapot. The crafts should be well aware of this productive force of purpose: more serving, less expressing.

To speak further about the exceptions other than the artists: there are those who act as a sort of conscience for industry. They are the ones who take the time and trouble to obey purpose and material devotedly and to follow a sensitivity toward form in developing an object that may be produced by industrial methods and may be mass-produced. I suppose "design " is the term for this work, more specifically "industrial design." But this term does not always embrace the attitude which I mean here, that of the artist; nor the results which are nonsubjective and are subservient to the purpose.

Whether the result is a unique object or a mass-produced one is hardly of concern, as long as the work is approached in the submissive manner of the artist. And here our modern world owes equal gratitude to the engineer, the chemist, all those who contribute to the world of things in this manner.

So this is the direction in which my thoughts run, trying to follow the two lines developed here, and I try to avoid the twilight.

February 1961

One of the most ancient crafts, hand weaving is a method of forming a pliable plane of threads by interlacing them rectangularly. Invented in a pre-ceramic age, it has remained essentially unchanged to this day. Even the final mechanization of the craft through introduction of power machinery has not changed the basic principle of weaving.

Other techniques had been devised to the same end: single element techniques— looping, netting, knitting, crocheting—and multiple element techniques—knotting, coiling, twining, braiding. In weaving, in the latter group, one system of threads, the warp, crosses another one, the weft, at right angles and the manner of intersecting forms the different weaves.

Gradually the various phases of manipulating warp and weft were mechanized until the technique of weaving surpassed all others in efficiency.

Whereas single-thread methods can be handled with few tools, weaving needs more complicated equipment since the warp has to be given tension. The device giving such tension is the loom. Weaving, then, is the process of passing the weft between taut, alternately raised warps, as in the basic plain weave, or between other combinations of selected warps, and pressing it into place.

Earliest weaving was done on the warp-weight loom, where warps were suspended from an upper bar and weighted at bottom. Weaving here progressed downward, unlike other weaving. It was used in ancient Greece and, more recently, by Indians of the North Pacific American coast. Next came the two-bar loom, with warp stretched from bar to bar, or, for extended length, wound onto the bars. Used either vertically or horizontally, the warp was held taut by a framework or stakes in the ground. Early Egyptian records show weaving on such a loom which, in vertical position, is also the tapestry loom of today.

Another loom, allowing for subtly adjustable tension, therefore finer weaving, is the back-strap loom, in which the lower bar is attached to a belt around the waist of the weaver, who, leaning forward or backward can tighten or slacken the warp. This loom made possible the extraordinary textile achievements of pre-Columbian Peru and is still found in remote regions of Asia and parts of Central and South America.

The intersecting weft, crossing between raised and lowered warps, was first inserted without tool, the extra length being wound into little bundles, as today in tapestry weaving; i.e., pictorial weaving. Later the weft was wound onto sticks and released as it traversed the warp. Finally, to introduce the weft faster and in greater length, it was wound on bobbins, inserted into boatlike shuttles, and thrust across the opened warp (the shed) in hand as well as in power looms.

To beat the weft into place, a weaver's sword of wood was an early instrument. Later a comblike "reed" was introduced, combining warp spacing with pounding of the weft. Suspended from the loom framework, the reed swings against the woven fabric, pressing successive wefts against it.

A first device for speeding up the selection of warps between which the weft passes was the shed-rod, carrying raised warps. To raise the opposite warps, an ingenious device, called a heddle, was introduced. The warps running under the shed-rod were tied with string-loops to a second rod, the heddle-rod, and they now could be raised past those on the shed-rod with one upward motion. Later, series of heddle-rods, replacing the shed-rod, facilitated the production of weaves based on more complex warp operation than that demanded for the plain weave, based on the principle of opposites.

In the medieval loom, the heddle-rods, now called shafts or harnesses, were suspended from the framework, similar to the pounding device, and were attached to foot treadles, as they are on hand looms today. They are still found on power looms. Though of incalculable value in saving time, this invention limited the thus far unlimited, primitive warp selection.

To regain some of the early freedom, the highly developed draw-loom was devised.

Chinese in origin, developed for elaborate pattern weaving, such as brocades and damasks, it was later adopted in Europe. It was superseded by a further mechanized warp-selection method, Jacquard weaving, still in use today, though transferred during the past century to power-driven machinery.

Among high achievements in hand weaving, Coptic as well as early Peruvian weaving must be recognized, the latter surpassing perhaps in inventiveness of weave structure, formal treatment, and use of color, other great textile periods. In fact practically all known methods of weaving had been employed in ancient Peru, and also some types now discontinued.

Today, hand weaving is practiced mainly on the medieval shaft loom with few harnesses. No longer of consequence as a manufacturing method in an industrial age, it concerns itself chiefly with fabrics for decorative use. Increasingly, though, industry is turning to hand weavers for new design ideas, worked out on hand looms, to be taken over for machine production. Hand weaving is included in the curriculum of many art schools and art departments of colleges and universities, as an art discipline able to convey understanding of the interaction between medium and process that results in form. It has survived through the ages as an art form in tapestry.

Hand weaving has also been taken up in the field of occupational therapy, having, though, as its aim there neither an educational nor an artistic end but solely that of rehabilitation.

It should be realized that the development of weaving is dependent also upon the development of textile fibers, spinning and dyeing, each a part of the interplay resulting in a fabric. Recent advances in the production of synthetic fibers and new textile finishes are having profound effect upon the weaving of cloth.

1963

DESIGNING AS VISUAL ORGANIZATION

It is safe, I suppose, to assume that today most if not all of us have had the experience of looking down from an airplane onto this earth. What we see is a free flow of forms intersected here and there by straight lines, rectangles, circles, and evenly drawn curves; that is, by shapes of great regularity. Here we have, then, natural and man-made forms in contradistinction. And here before us we can recognize the essence of designing, a visually comprehensible, simplified organization of forms that is distinct from nature's secretive and complex working.

Or on a beach, we may find a button, a bottle, a plank of wood, immediately recognizable as "our" doing, belonging to our world of forms and not to that which made the shells, the seaweed, and the undulated tracings of waves on sand. Also we can observe the counterplay of the forming forces: the sea slowly grinding an evenly walled piece of glass, foreign to it in shape and substance, into a multiform body suitable for adoption into its own orbit of figuration. On the other hand, we see the waves controlled, where dams and dikes draw a rigid line between land and water.

To turn from "looking at" to action: we grow cabbages in straight rows and are not tempted by nature's fanciful way of planting to scatter them freely about. We may argue that sometimes we follow her method and plant a bush here and another there, but even then we "clear" the ground. Always, though sometimes in a way that is roundabout and apparent only as an underlying scheme of composition, it is clarity that we seek. But when the matter of usefulness is involved, we plainly and without qualification use our characteristics: forms that, however far they may deviate in their final development, are intrinsically geometric.

If, then, it appears that our stamp is or should be an immediate or implicit lucidity, a considered position, a reduction to the comprehensible by reason or intuition in whatever we touch (confusion always gets a negative rating), we have established a

basis for designing—designing in any field. From city-planning to the planning of a house or a road, from the composing of music to the formulation of a law, the weaving of a fabric, or the painting of a picture—behind the endless list of things shaped is a work of clarification, of controlled formulation.

By using the term "designing" for all these varied ways of pre-establishing form, we are, of course, doing some violence to the word. "Designing" usually means "giving shape to a useful object." We do not speak of designing a picture or a concerto, but of designing a house, a city, a bowl, a fabric. But surely these can all be, like a painting or music, works of art. Usefulness does not prevent a thing, anything, from being art. We must conclude, then, that it is the thoughtfulness and care and sensitivity in regard to form that makes a house turn into art, and that it is this degree of thoughtfulness, care, and sensitivity that we should try to attain. Culture, surely, is measured by art, which sets the standard of quality toward which broad production slowly moves or should move. For we certainly realize that there are no exclusive materials reserved for art, though we are often told otherwise. Neither preciousness nor durability of material are prerequisites. A work of art, we know, can be made of sand or sound, of feathers or flowers, as much as of marble or gold. Any material, any working procedure, and any method of production, manual or industrial, can serve an end that may be art. It is interesting to see how today's artists, for example our sculptors, are exploring new media and are thereby fundamentally changing the sculptural process from the traditional method of cutting away to one of joining. They are giving us, instead of massive contour, exposed structure; instead of opaqueness, transmission of light. Obviously, then, regardless of the material and the method of working it, designing is or should be methodical planning, whether of simple or intricately organized forms; and if done imaginatively and sensitively, designing can become art.

Let us pursue this matter of designing a little further, now that we have established in our mind where its beginning lies and where its ultimate goal.

Since our concern here is to explore the process of designing and not to analyze the design done, we should try to put ourselves in the position of the "doer," the

one who is making a thing new in form. It may appear as though I am addressing myself now only to professionals. But though I know that designing takes practical knowledge of the work involved, still I am much aware that the dividing line between the trained and the untrained becomes blurred when both are facing the new. For anyone who is making something that previously did not exist in this form is, at that point, of necessity an amateur. How can he know how this thing is done that never has been done before? Every designer, every artist, every inventor or discoverer of something new is in that sense an amateur. And to explore the untried, he must be an adventurer. For he finds himself alone on new ground. He is left to his own devices and must have imagination and daring. All decisions here are his own, and only he is responsible. But though it is he who is in charge, he feels himself to be only an intermediary who is trying to help the not-yet-existent turn into reality. Standing between the actual and that which may be, the conscientious designer, as I see it, seeks to forego his own identity in order to be able more impartially to interpret the potential. For the less he himself, his subjectivity, stands in the way of the object that is to take form, the more it will have "objective" qualities and thereby will also take on a more lasting character than it otherwise could. And just as concern with material and method of treatment engages his conscious mind and frees the formative energies that we recognize when crystallized as ideas, so also, and to the same end, does the tête-à-tête with the still-amorphous absorb his self-awareness.

Let me illustrate my point with a specific design project, a textile problem in our case. To be more easily understood, it will be one of modest scope. Nevertheless, I hope it will be possible to trace the various steps involved in its realization and thereby to have a look at some of the facets of this phenomenon that is designing.

Let us assume that the task is to design a wall-covering material, quite specifically one suited for museum walls; that is, a material for a specific practical use. As conscientious designers in our passive role, we will let the fabric-to-be specify its own future characteristics, such as perhaps being dust-repellent, nonfading, woven suffi-

ciently closely to cover up any irregularities of the wall, and, for the same purpose, having a certain amount of bulk. Furthermore, it should neither stretch nor sag, and it should be possible to clean it by brushing or wiping. Also, any small nail holes driven into it should close easily after removal of the nail. It should, in all probability, be light in color, perhaps even light-reflecting, possibly flame-retarding, and certainly mothproof if not mildew-proof. In regard to general complexion: it should be quiet enough so as not to compete with any artwork put on it or placed before it; that is, it should be subservient, not dominating.

Taking these suggestions, we will be led to a definite choice of raw material, of weave construction, and of color, all interactive, as will be apparent. Also, these suggestions will be decisive in the question of formal treatment—whether to choose checks or stripes, elaborate patterns or a uniform surface. An extension into the field of pictorial invention is ruled out here because of the supporting and not independent character the fabric is to have.

To go into further detail: what in particular are the proposals that have come to us from the object-to-be since its inception? It has circumscribed the range of the raw material that might be suitable. Wool, for instance, will have to be excluded as neither dust-repellent nor mothproof without special chemical treatment, while any fiber with a somewhat coated surface, such as linen or raffia or a strawlike synthetic fiber, might fit the requirements. Such a raw material also would have a certain stiffness and bulk that would prevent sagging and would help the fabric keep its shape. However, without additional processing it would not be flame-retarding, should that be required, as it sometimes is in public buildings. As to weave construction: all specifications point to a plain weave, the simplest construction existent, which makes a somewhat stiff material, in contrast to a satin or a twill weave, which would result in a more pliable fabric not desired here. The plain weave also produces, in a balanced relationship of warp and weft, a more or less porous material specifically suited to take care of the nail-hole problem. In addition, its use is a safeguard against the fabric's sagging or stretching out of shape, aided in this by the suggested

raw materials, which also are inelastic in character. It also is an economical weave using less yarn than most others, a consideration that is often vital.

Continuing in our attitude of attentive passiveness, we will also be guided in our choice of color, though here only in part. For our response to color is spontaneous, passionate, and personal, and only in some respects subject to reasoning. We may choose a color hue—that is, its character as red or blue, for instance—quite autocratically. However, in regard to color value—that is, its degree of lightness or darkness— and also in regard to color intensity—that is, its vividness—we can be led by considerations other than exclusively by our feeling. As an example: our museum walls will demand light and have a color attitude that is nonaggressive, no matter what the color hue, and whether there is an overall color or a play of colors.

However, one factor may influence even our impulsive choice of color, and that is the practical question of colorfastness to light and, where this is necessary, to washing. Different colors vary of course in this respect. The coloring matter in textiles is a dye that penetrates the fibers of the material, unlike color pigment or paint, which is applied to the surface only. The action, therefore, of the dye on different fibers has to be taken into account and will affect, in turn, the choice of the raw material. Also, the dye process itself has to be considered. In piece dyeing, for instance, the whole finished fabric is immersed in the dye bath to give it a uniform color, while in yarn dyeing, as the name suggests, the yarn is dyed before it is woven, thereby allowing a fabric to be built of different color units. Only the latter, as we should be aware, allows for the full realization of the means within the weaver's sphere.

We have again reached a point where we can think in general terms, for the issue of the specific formal domain within which a craft operates has wide implications. Architecture, for instance, is concerned with space: with enclosing space, with extending into space, and with gravity and tension. Though sculptural elements (arrangement of masses), painterly elements (light, shadow, color), and textural elements (inherent structure of material and marks of working it) are also present, these should speak only quietly, not dominantly. Similarly, we can delineate the weaver's province.

The meaning of the word "textural" covers that quality which is the essence of weaving. It is the result, apparent on the surface, of the manner in which interdependent thread units are connected to form a cohesive and flexible whole. This surface play, of structural origin, can be accentuated or subdued through the choice of yarn and its characteristics—glossiness, dullness, knobbiness, etc.—and of color. It becomes obvious now, I believe, why the above-mentioned piece-dyeing process diminishes rather than enhances the quintessence of weaving, for it bridges over and thereby obscures with one color the separate functions of the structural elements.

If, in regard to visual articulation, texture, produced through the interlocking of threads, is the focal point in weaving, those peripheral components that can variegate it come only second in the order of importance. Properties such as warmth—of paramount importance in textiles used for clothing—do not belong to the vocabulary of form. There, then, is the quality of the yarn that is to make the fabric, whether it is rough or smooth, lustrous, shaggy, downy, uneven, etc.—qualities that are able to underline the structural appearance of the fabric or to restrain it. Today, with the rediscovery of textural interest, this secondary element of composition, yarn character, is often used as a substitute for the primary one, which is structural in nature. As a result, we find an exaggerated emphasis on fancy yarns to make up for a thread construction that is dull. In fact, this shift from structural effects to predominantly yarn effects today holds back a textile development that should center on construction as the original focal point.

Color comes only third in importance among the elements of composition within the weaver's dimensions. By giving different colors to the differently functioning threads, the structural character of the weaving will be intensified. In addition, color, more acutely than texture, conveys emotional values; but, if it is introduced as too independent an agent, it may carry the weaving outside of its own territory into the painterly province. When color in weaving moves into a first place, suppressing the main textile ingredients, we find a regression of the art of weaving. Examples, historical and contemporary, may be found in some of the pictorial tapestries woven from

painters' designs—Raphael's, Picasso's, Rouault's, etc. Many of these works, lacking in textural and structural interest, have moved to the very edge of the weaver's realm; and, though perhaps impressive as pictorial compositions, they are often of little consequence as pictures or as weavings.

We are ready, I believe, to resume work on our particular task. We have found ourselves limited to a definite range of raw material and of color and have been led to a suitable thread construction, the plain weave. Now that we have become aware of the interplay of fiber, color, and weave, let us see where another step in the act of condensation will take us.

In regard to fiber, we found linen, raffia, and a strawlike synthetic fiber acceptable. Of these, linen is best suited as warp material here. It recommends itself for the purpose at hand by its relatively inelastic character, which lessens the chance that the fabric may stretch out of shape or sag. In addition, linen has a natural color that is a grayish tan. It has this to say for itself: it will not fade even when exposed to light for a long period; it has an easy color-relationship to any woodwork—floors, for instance—and its color will show dust less readily than most; it is mothproof though not mildew-proof. The slight stiffness of the linen fiber will increase that of the plain weave construction and also will add to the porousness that has been found desirable. When intersected by a weft of strawlike synthetic yarn, white and glossy in its original state, the dull natural linen will take on life by contrast, and a subtle play in natural-to-white tones could be developed, as well as a play on the scale from dull to sparkling, even light-reflecting. Again, this original white will stay white under exposure to light, and the hard surface of the fiber will retain only a small amount of dust. Since, where large areas are involved, the problem of fading is unavoidable, a solution that circumvents dyeing altogether can only be welcomed. The synthetic fiber is mothproof and mildew-proof and, intersecting the linen, it will reduce by the percentage of its use the mildew problem, unsolved in the case of linen. Here, now, we have a fabric that largely answers the outlined requirements. It formed itself, actually, and what remains to be determined is mainly the formal organization of the elements.

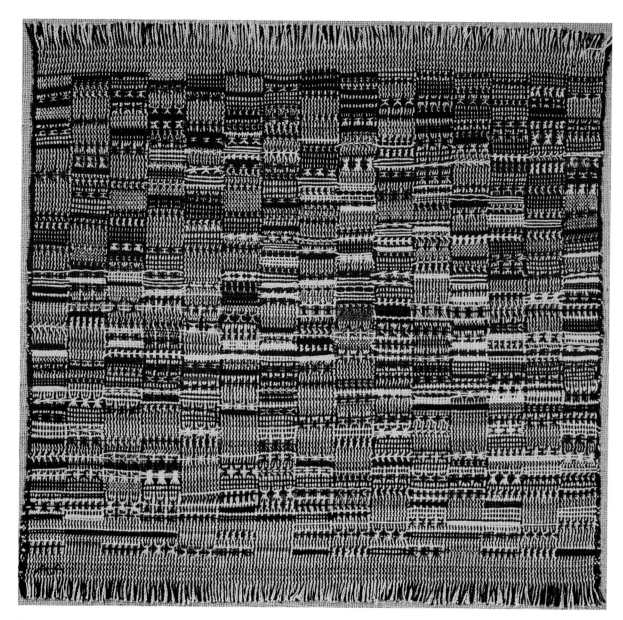

Open Letter, 1958.
Cotton, 58.4 × 59.7 cms (23 × 23 ¹/₂ ins).
The Josef and Anni Albers Foundation.
Photo: Tim Nighswander.

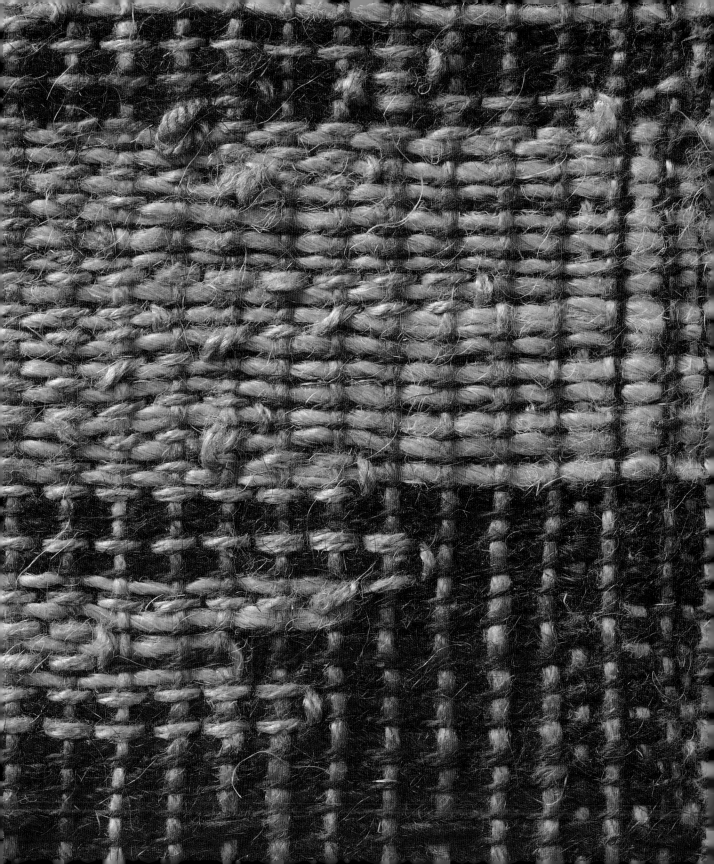

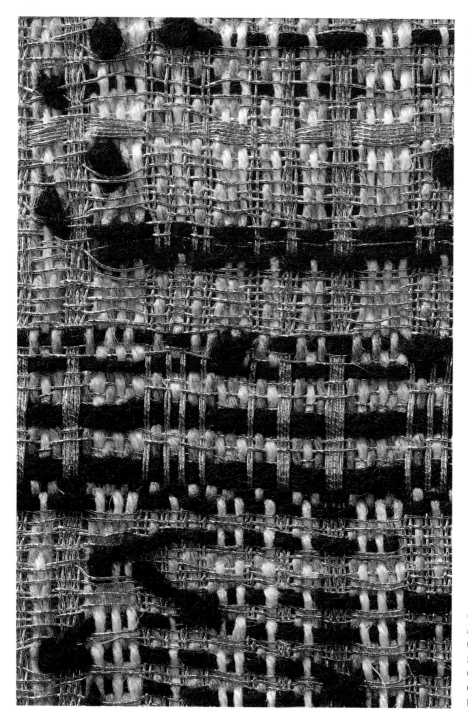

Haiku, 1961 (detail). Cotton, hemp, metallic thread, 57.2 × 18.4 cms (22 $^1/_2$ × 7 $^1/_4$ ins). The Josef and Anni Albers Foundation. Photo: Tim Nighswander.

Opposite:
In the Landscape, 1958 (detail). Cotton and jute, 29.5 × 98.5 cms (11 $^5/_8$ × 38 $^{13}/_{16}$ ins). Collection of Dr. William and Constance G. Kantar. Photo: Tim Nighswander.

Fabric sample, ca. 1948. Harnessmaker's thread, 15.9 × 8.2 cms (6 1/4 × 3 1/4 ins). The Museum of Modern Art, New York. Gift of Josef Albers. Photograph © 2000 By The Museum of Modern Art, New York. 450.70.99

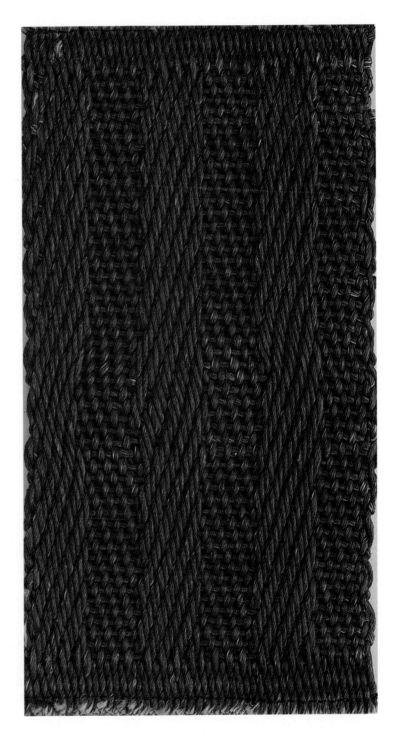

We now have arrived at that stage of designing which demands our finest "ear," for we must try to discern the formal currents of our period in history that are on the verge of crystallizing and that may become part of our language of form, or may again become part of it. Texture—the word I tried to use only in its exact meaning and avoided in its fashionable, loose sense—is, for instance, one of the formal elements that has been of little or no interest for a long time but has again become one of today's stylistic components. We must learn to sense those elements of form that respond to our formal needs. We like things today that are light—light as the opposite of heavy and light as the opposite of dark. We must learn to detect, in particular occasions, manifestations of general developments; that is, we must learn to foresee. And to foresee we need a contemplative state of mind.

To return to our wall-covering project: with the matter of formal composition, the general air that the fabric is to have becomes the center of our concern. We have in our hands powerful means of articulation—directional elements such as verticals, horizontals, diagonals, squares as basic examples, or, in the weaver's terms, warp or weft stripes, twills, checks, etc. We are able to convey impressions of height, of width, of boldness, of reticence, of gaiety or somberness, of monumentality or caprice, all within, though modified by, the thus-far established framework. For the subservient character we have sought for the fabric from the start directs our decisions and precludes loud instrumentation.

Again, we are here led away from pronounced lineation and contours toward a surface active only through the slight optical vibration of intersecting raised and lowered threads—shiny and dull, lighter and darker, tan and white. This material will be quiet yet alive, responsive to lighting, compliant in its relationship to objects more demonstrative than itself in color and shape; a background for a flower, a face, a painting, a sculpture.

From here we can move on to a wider point of view. We may contend that the world around us puts us under great strain and that we need calm and quietness wherever we can get them. Today, we should try to counteract habits that only rarely leave us

time to collect ourselves. Every hour on the hour we seem to need the latest and, as it turns out, usually the most unsettling and gloomy report, often, when seen in retrospect, of nonessentials. Yesterday's paper is wastepaper. Wisdom and insight hardly make headlines. Nevertheless, we are seldom found—on train or plane, on bus or boat, or in any given moment of imposed restraint of action—without a bundle of distractions in our hand in the form of papers or magazines.

And though it may appear that we are straying from our line of thought, it is on the contrary here on the ground of philosophy and morals that attitudes and convictions, the starting points of our actions, are formed. Two matters may here be of special concern to the conscientious designer and may make him stop and think or, perhaps, think and stop. The first is that with his help another object will be added to the many that are already taking our attention and our care, another object to distract us. (Our households contain hundreds of objects.) The second is that by trying to give this object its best possible shape, by trying to make it as timeless as possible—that is, not dictated by short-lived fashion—and by finding for it a form as anonymous as possible—that is, a form unburdened by dominantly individual traits of the planner—the designer finds himself in direct conflict with the economic pattern of our time. For the economy of today is built largely upon change, and the "successful" designer, a term I have not used before, will have to consider the matter of "calculated obsolescence." We are urged today to want more and more things, and we are subjected to a vigorous campaigning for always newer things, things that are not necessarily newer in performance. We are asked to shift from red to blue or from this bit of trimming to that for the questionable reason or unreason of fashion. It is evident, I think, that the designer who takes the longer view is by no means identical with the "successful" designer.

We have watched the coming into being of our object and have seen how medium and method of work present *themselves* to us and thereby limit our range of choice. Among other components to be considered, contributing to such limitation, is that of price. This, above others, is often felt as a restriction on the freedom of the designer. I have shown, I think, that I do not believe in the sovereignty of the designer, and I

cannot concur with the view that such a limitation must mean frustration. Rather, to my mind, limitations may act as directives and may be as suggestive as were both the material itself and anticipated performance. Great freedom can be a hindrance because of the bewildering choices it leaves to us, while limitations, when approached open-mindedly, can spur the imagination to make the best use of them and possibly even to overcome them.

As much a limiting factor as price, for instance, is the matter of production. Whether production is by craft or by industrial method, this many-sided problem can be as stimulating as the others discussed earlier. Any one of them can serve as starting point in the process of crystallization that we have followed. It is interesting to note here that mechanized production, however advanced, always means a reduction in the range of possibilities, though usually it also means an increase in exactitude, speed, and quantity of output, when compared to anything done with the ancient instrument that is our hand. As to our immediate concern, the material for the wall: it constitutes no problem for machine or hand. The construction is of the simplest kind, demanding nothing but the simplest type of loom, and the choice between industrial or manual production is dependent solely on the quantity of material involved.

Today such matters as, for instance, that the finished object be photogenic can influence designing. In a time that depends greatly for success upon photographic reproduction, a consideration of this sort—in itself surely beside the point—can become a factor that may have to be taken into account. So, too, may the powerful figure of the client and, in textiles, the buyer, who often bring to the project preconceived viewpoints that may be right but, alas, can be wrong.

As you will have noticed, I have made no distinction between the craftsman designer, the industrial designer, and the artist—because the fundamental, if not the specific, considerations are the same, I believe, for those who work with the conscience and apperception of the artist. With surprise and reassurance I recently came across a statement by the painter Lyonel Feininger, who speaks of one of his pictures as having "painted itself."

At the beginning we spoke here of the comprehensible orderliness which underlies all our doing and whose ultimate form is also that of art. Material form becomes meaningful form through design, that is, through considered relationships. And this meaningful form can become the carrier of a meaning that takes us beyond what we think of as immediate reality. But an orderliness that is too obvious cannot become meaningful in this superior sense that is art. The organization of forms, their relatedness, their proportions, must have that quality of mystery that we know in nature. Nature, however, shows herself to us only in part. The whole of nature, though we always seek it, remains hidden from us. To reassure us, art tries, I believe, to show us a wholeness that we can comprehend.

1965

All progress, so it seems, is coupled to regression elsewhere. We have advanced in general, for instance, in regard to verbal articulation—the reading and writing public of today is enormous. But we certainly have grown increasingly insensitive in our perception by touch, the tactile sense.

No wonder a faculty that is so largely unemployed in our daily plodding and bustling is degenerating. Our materials come to us already ground and chipped and crushed and powdered and mixed and sliced, so that only the finale in the long sequence of operations from matter to product is left to us: we merely toast the bread. No need to get our hands into the dough. No need—alas, also little chance—to handle materials, to test their consistency, their density, their lightness, their smoothness. No need for us, either, to make our implements, to shape our pots or fashion our knives. Unless we are specialized producers, our contact with materials is rarely more than a contact with the finished product. We remove a cellophane wrapping and there it is—the bacon, or the razor blade, or the pair of nylons. Modern industry saves us endless labor and drudgery; but, Janus-faced, it also bars us from taking part in the forming of material and leaves idle our sense of touch and with it those formative faculties that are stimulated by it.

We touch things to assure ourselves of reality. We touch the objects of our love. We touch the things we form. Our tactile experiences are elemental. If we reduce their range, as we do when we reduce the necessity to form things ourselves, we grow lopsided. We are apt today to overcharge our gray matter with words and pictures, that is, with material already transposed into a certain key, preformulated material, and to fall short in providing for a stimulus that may touch off our creative impulse, such as unformed material, material "in the rough."

Concrete substances and also colors per se, words, tones, volume, space, motion— these constitute raw material; and here we still have to add that to which our sense of

touch responds—the surface quality of matter and its consistency and structure. The very fact that terms for these tactile experiences are missing is significant. For too long we have made too little use of the medium of tactility. *Matière* is the word now usually understood to mean the surface appearance of material, such as grain, roughness or smoothness, dullness or gloss, etc., qualities of appearance that can be observed by touch and are consequently not concerned with lightness or darkness. There seems to be no common word for the tactile perception of such properties of material, related to inner structure, as pliability, sponginess, brittleness, porousness, etc.

Surface quality of material, that is, *matière*, being mainly a quality of appearance, is an aesthetic quality and therefore a medium of the artist; while quality of inner structure is, above all, a matter of function and therefore the concern of the scientist and the engineer. Sometimes material surface together with material structure are the main components of a work; in textile works, for instance, specifically in weavings or, on another scale, in works of architecture. Parallel to this overlapping of outer and inner characteristics in a work is the overlapping of artistic, scientific, and technological interests on the part of the weaver or the architect. The pendulum of their work swings from art to industrial science.

Structure, as related to function, needs our intellect to construct it or, analytically, to decipher it. *Matière*, on the other hand, is mainly nonfunctional, nonutilitarian, and in that respect, like color, it cannot be experienced intellectually. It has to be approached, just like color, nonanalytically, receptively. It asks to be enjoyed and valued for no other reason than its intriguing performance of a play of surfaces. But it takes sensibility to respond to *matière*, as it does to respond to color. Just as only a trained eye and a receptive mind are able to discover meaning in the language of colors, so it takes these and in addition an acute sensitivity to tactile articulation to discover meaning in that of *matière*. Thus the task today is to train this sensitivity in order to regain a faculty that once was so naturally ours.

If we want to concentrate, then, on this segment of our work, that is, tactility, it is better to put on blinders and exclude what might distract us: considerations of color

and inner structure. We will try to approach material with just this in mind: to discover its inherent surface quality or the one which we might be able to give to it directly by working it or indirectly by influencing it, for instance, through contrast with neighboring materials. We will look around us and pick up this bit of moss, this piece of bark or paper, these stems of flowers, or these shavings of wood or metal. We will group them, cut them, curl them, mix them, finally perhaps paste them, to fix a certain order. We will make a smooth piece of paper appear fibrous by scratching its surface, perforating it, tearing it, twisting it; or we will try to achieve the appearance of fluffy wool by using feathery seeds. What we are doing can be as absorbing as painting, for instance, and the result can be, like a painting, an active play of areas of different complexion. We are here revitalizing our tactile sense and are not dealing with real weaving.

Now, since our interest is textile form and not the freer form of the painter, we will have to be aware of those conditions that will make of our surfaces textile surfaces. If we try to have a rhythm in them of horizontals, of verticals, of horizontals and verticals, or of staggered diagonals, we will arrive at results that resemble actual textiles, for the dominant textile elements are present: the straight lines of the directions and the surface activity. Color enters in at this point only as a by-product—since of course nothing is colorless—not as a focal point. Any color effect is, for the moment, incidental, not intentional.

We will learn to use grain and gloss, smoothness, roughness, the relief quality of combined heavy and fine material—those elements of form that belong to the aesthetic side of tactile experience—and will find them equally as important as areal divisions and color.

Our concentration in this direction will serve two purposes: first, the important activating of our latent perceptivity of *matière;* second, the gaining of a medium suited to demonstrate, in advance of any actual execution, how a proposed design will look in its tactile properties, which are difficult to show by drawing or painting: a tactile blueprint. We will have learned to think of surface characteristics as means fully as

expressive as line and color. We will also have become conscious of this medium as a distinctive textile trait. If a sculptor deals mainly with volume, an architect with space, a painter with color, then a weaver deals primarily with tactile effects. But, as was said above, qualities of the inner structure are as much part of a textile as are effects of outer tactile surface. The structure of a weaving, as well as the fibers chosen for the work, can bring about an interesting surface. There is an intricate interplay between the two. A knowledge of textile construction is thus essential for *matière* effects, as it is for the organization of a weaving as a whole. Our experiments in surface effects are therefore to be understood only as exercises to increase our awareness of surface activities, since the actual work of weaving is only in part concerned with the epidermis of the cloth. The inner structure together with its effects on the outside are the main considerations. Embroidery, on the other hand, is a working of just the surface, since it does not demand that we give thought to the engineering task of building up a fabric. For this very reason, however, it is in danger of losing itself in decorativeness; for the discipline of constructing is a helpful corrective for the temptation to mere decoration.

Our experience of gaining a representational means through the use of different surface qualities leads us to the use of illusions of such qualities graphically produced, though not by the means of representational graphic—that is, the modulated line. Drawing or print that shows hatching or stippling, rippled or curled lines, etc., and thus has a structural appearance, can be used to produce, if not actual tactile surfaces, the illusion of them. The tactile-textile illusions produced on the typewriter may illustrate this point. These varied experiments in articulation are to be understood not as an end in themselves but merely as a help to us in gaining new terms in the vocabulary of tactile language.

1965

A short while ago I had a visit from a ten-week-old baby who looked at me wide eyed and I thought somewhat puzzled and was struggling as if trying to tell me something and did not know how.

And I thought how often did I feel like that, not knowing how to get out what wanted to be said.

Most of our lives we live closed up in ourselves, with a longing not to be alone, to include others in that life that is invisible and intangible.

To make it visible and tangible, we need light and material, any material. And any material can take on the burden of what had been brewing in our consciousness or subconsciousness, in our awareness or in our dreams.

Now, material, any material, obeys laws of its own, laws recognizably given to it by the reigning forces of nature or imposed by us on those materials that are created by our brain, such as sound, words, colors, illusions of space—laws of old or newly invented. We may follow them or oppose them, but they are guidelines, positive or negative.

The human brain is a computer. Total chaos is not human. In the cosmos we try to unravel the riddle of its order. Television, my great teacher, tells me that astronomers are finding ever more simplifications of order, unifying ever more everything.

How do we choose our specific material, our means of communication? "Accidentally." Something speaks to us, a sound, a touch, hardness or softness, it catches us and asks us to be formed. We are finding our language, and as we go along we learn to obey their rules and their limits. We have to obey, and adjust to those demands. Ideas flow from it to us and though we feel to be the creator we are involved in a dialogue with our medium. The more subtly we are tuned to our medium, the more inventive our actions will become. Not listening to it ends in failure. (Years ago, I once asked John

Cage how he had started to find his way. He will not remember it. "By chance" was the answer.) Students worry about choosing their way. I always tell them, "you can go anywhere from anywhere."

In my case it was threads that caught me, really against my will. To work with threads seemed sissy to me. I wanted something to be conquered. But circumstances held me to threads and they won me over. I learned to listen to them and to speak their language. I learned the process of handling them.

And with the listening came gradually a longing for a freedom beyond their range and that led me to another medium, graphics. Threads were no longer as before three-dimensional; only their resemblance appeared drawn or printed on paper.

What I had learned in handling threads, I now used in the printing process. Again I was led. My prints are not transfers from paintings to color on paper as is the usual way. I worked with the production process itself, mixing various media, turning the screens. . . .

What I am trying to get across is that material is a means of communication.

That listening to it, not dominating it makes us truly active, that is: to be active, be passive.

The finer tuned we are to it, the closer we come to art.

Art is the final aim. In an interview recently Maximilian Schell, the actor, said, "art is for realizing dreams."

February 25, 1982

Anni Albers's writings frequently originated as public talks or lectures that were subsequently published in journals or collected in the two published volumes of her writings, *Anni Albers: On Designing* (1959, 1962, and 1971) and *Anni Albers: On Weaving* (1965). Some were never published and are known only as manuscripts or typescripts. Most of the original manuscripts have disappeared. Two of the writings in the present collection, "Art—A Constant" and "Conversations with Artists," are known only from their publication in *Anni Albers: On Designing*, where they were dated 1939 and 1961 respectively. Though "Conversations with Artists" clearly originated as a talk, the circumstances are unknown.

I. BOOKS

Anni Albers: On Designing. New Haven, Conn.: The Pellango Press, 1959. Second edition, Middletown, Conn.: Wesleyan University Press, 1962. First paperback edition, Wesleyan University Press, 1971.
 Contents: Design: Anonymous and Timeless; Constructing Textiles; The Pliable Plane: Textiles in Architecture; Refractive; One Aspect of Art Work; A Start; Weaving at the Bauhaus; Art—A Constant; Work with Material; Designing; Conversations with Artists; A Structural Process in Weaving.

Anni Albers: On Weaving. Middletown, Conn.: Wesleyan University Press, 1965.
 Contents: Weaving, Hand; The Loom; The Fundamental Constructions; Draft Notation; Modified and Composite Weaves; Early Techniques of Thread Interlacing; Interrelation of Fiber and Construction; Tactile Sensibility; Tapestry; Designing as Visual Organization.

Pre-Columbian Mexican Miniatures: The Josef and Anni Albers Collection. With Ignacio Bernal and Michael D. Coe. New York: Praeger, 1970.

II. PUBLISHED ARTICLES

"Bauhausweberei." *Junge Menschen* (Hamburg) 5:8, Nov. 1924.

"Wöhnökonomie." In *Neue Frauenkleidung und Frauenkultur*, vol. 1. Karlsruhe, 1925. Special Bauhaus supplement.

 Published before her marriage to Josef Albers in 1925, under Albers's maiden name, Annelise Fleischmann.

"Weaving at the Bauhaus." In *Bauhaus: 1918–1928*. Ed. Herbert Bayer, Walter Gropius, and Ise Gropius. New York: The Museum of Modern Art, 1938.

 Reprinted in *Anni Albers: On Designing* (1959 and 1971).

"Work with Material." *Black Mountain College Bulletin* 5, 1938.

 Reprinted in *College Art Journal* 3:2, Jan. 1944, pp. 51–54, and in *Anni Albers: On Designing* (1959 and 1971).

"Handweaving Today: Textile Work at Black Mountain College." *The Weaver* 6:1, Jan.–Feb. 1941, pp. 3–7.

"Designing." *Craft Horizons* 2:2, May 1943, pp. 7–9.

 A typescript version of this article, annotated in pencil by Albers and dated March 15, 1942, indicates that Albers first presented it as a talk to the Weaving Workshop of North Carolina on March 15, 1942.

"We Need the Crafts for Their Contact with Materials." *Design* 46:4, Dec. 12, 1944, pp. 21–22.

 Reprinted and retitled "One Aspect of Art Work" in *Anni Albers: On Designing* (1959 and 1971).

"Constructing Textiles." *Design* 47:8, Apr. 4, 1946. Special issue on Black Mountain College.

 Reprinted in *Anni Albers: On Designing* (1959 and 1971) and in Nicholas Fox Weber and Pandora Tabatabai Asbaghi, *Anni Albers* (New York: Guggenheim Museum, 1999).

"Design: Anonymous and Timeless." *Magazine of Art* 40:2, Feb. 1947, pp. 51–53.

 Reprinted in *Anni Albers: On Designing* (1959 and 1971). Edited and reprinted as "On the Designing of Textiles and the Handweaver's Place in Industry," *American Fabrics* 50, summer 1960, pp. 89–99.

"Fabrics." *Arts and Architecture* 65, Mar. 1948, p. 33.

"Weavings." *Arts and Architecture* 66, Feb. 1949, p. 24.

Review of Ben Nicholson's *Paintings, Reliefs, Drawings*, with introduction by Herbert Read. *Magazine of Art* 43, Jan. 1950, pp. 36–37.

"The Pliable Plane: Textiles in Architecture." *Perspecta: The Yale Architectural Journal* 4, 1957, pp. 36–41.

> Abridged and reprinted as "Fabric: The Pliable Plane," *Craft Horizons* 18, Jul.–Aug. 1958, pp. 15–16.

"Weaving, Hand." *Encyclopaedia Britannica*, 1963.

> Reprinted as chapter one of *Anni Albers: On Weaving* (1965).

"A Start." Craft Horizons 29:5, Sept.–Oct. 1969.

> When Albers was invited to contribute an obituary for Gropius to *Craft Horizons* in 1969, she submitted this piece, written in 1947 for a publication on Gropius that was never realized.

III. UNPUBLISHED WRITINGS

"On Jewelry." Typescript of an untitled talk given at Black Mountain College, Mar. 25, 1942.

"Things Are Changing so Extraordinar[il]y Fast Today." Typescript, Oct. 1963.

"Craftsmanship." Typescript of a statement for a colloquium of the Associated Artists of Pittsburgh, 1964.

"Material as Metaphor." Typescript of Albers's statement as member of a panel, The Art/Craft Connection: Grass Roots or Glass Houses, at the College Art Association's 1982 annual meeting, Feb. 25, 1982.

> The panel was moderated by Rose Slivka, editor of *Craft International*, and the panelists were Anni Albers, John Cage, Lee Hall, Robert Malloy, Phillip Pavia, Jacqueline Rice, and Peter Voulkos.

ABOUT THE AUTHOR

Anni Albers (1899–1994) is known for her work in the field of textiles as an artist, a designer for industrial production, a lecturer, and a teacher. Born in Berlin, Germany, she started her art training in Berlin and Hamburg and became a student of the Bauhaus in Weimar and Dessau, where she met her husband, Josef Albers. From 1933 to 1949 she was assistant professor of art at Black Mountain College. The recipient of many awards and citations, Albers was presented the Gold Medal of the American Institute of Architects in the field of craftsmanship in 1961. She lectured at numerous museums and universities. Her work is in private collections and in leading museums including the Busch-Reisinger Museum, Harvard University; the Baltimore Museum of Art; the Bauhaus-Archiv, Berlin; the Museum Neue Sammlung, Munich; the Kunstgewerbe Museum, Zurich; the Museum of Modern Art, New York; and the Metropolitan Museum of Art, New York.